VISUAL QUICKSTART GUIDE

ADOBE PHOTOSHOP LIGHTROOM 2

Nolan Hester

Peachpit Press

Visual QuickStart Guide
Adobe Photoshop Lightroom 2
Nolan Hester

Peachpit Press

1249 Eighth Street
Berkeley, CA 94710
510/524-2178
510/524-2221 (fax)

Find us on the Web at: www.peachpit.com
To report errors, please send a note to errata@peachpit.com
Peachpit Press is a division of Pearson Education

Editor: Nancy Davis
Production Editor: David Van Ness
Compositor: David Van Ness
Proofreader: Valerie Witte
Indexer: FireCrystal Communications
Cover design: Peachpit Press
All example photographs: Nolan Hester

Notice of Rights

Notice of Liability

Trademarks

ISBN 13: 978-0-321-55420-8
ISBN 10: 0-321-55420-5

9 8 7 6 5 4 3 2 1

Printed and bound in the United States of America

Wait ... wait ... OK. Got the shot.

Thanks Mary.

Special Thanks to...

Nancy Davis, my editor, for making this book better in every way,

David Van Ness for making what is always a marathon into a journey worth taking, and

Emily Glossbrenner of FireCrystal for making this index a map of concepts rather than just a vocabulary list.

CONTENTS AT A GLANCE

TABLE OF CONTENTS

TABLE OF CONTENTS

INTRODUCTION

Welcome to *Adobe Photoshop Lightroom 2: Visual QuickStart Guide*. When Lightroom was first released early in 2007, it seemed as if digital photography's future had finally arrived in the here and now. Built from the ground up for digital photography, it ran on Windows and Mac. It didn't require a computer faster than you could afford. And Lightroom combined many of Adobe Photoshop's amazing tools with a simpler interface. Adjusting tone curves, always a bit mysterious in Photoshop, seemed easier and more straightforward.

In ways big and small, Lightroom felt like a photographic process instead of something installed on a computer. That's because Lightroom is organized around a "workflow" that reflects photography itself, starting with moving photos off of a camera into the computer and ending with either a print or screen image.

Lightroom does all this without ever touching the original photo. Unlike Photoshop, which writes over the pixels of your original photo with each save, Lightroom makes all its edits as software instructions, known as metadata. The edits are all stored in a database, which makes it possible to tweak the adjustments endlessly—and even apply them to another photo with a couple of clicks. That's no knock on Photoshop, which remains an essential tool for me and every other digital photographer. In fact, using Lightroom and Photoshop in tandem now seems so natural it's hard to imagine photography before Lightroom's arrival.

What's New in Lightroom 2?

Here are some of the most important improvements in Adobe Photoshop Lightroom 2:

Faster, bigger catalogs: Lightroom's catalog, which tracks your photos and every change in exposure or color you make to them, is now faster and simpler. Whereas Lightroom originally forced you to create multiple catalogs to avoid computer slowdowns, Lightroom 2 makes it possible to keep virtually all your photos in a single catalog. And the catalog now keeps tabs on photos stored on multiple hard drives, even when those drives are not currently connected to your computer. (For more information, see pages 26 and 107.)

Find it faster: The first version's tools for finding a particular photo frankly were a bit confusing. In Lightroom 2, what was scattered has been pulled together into a single Library Filter toolbar where you can find, sort, and filter in a couple of clicks. (For more information, see page 96.)

Local adjustment brushes: Lightroom has always been great at making photo-wide adjustments. But if you wanted to, say, lighten the exposure or adjust the color for a particular area in a photo, you had to switch over to Photoshop. With the introduction of local adjustment tools, Lightroom 2 gives digital photographers an easy-to-use digital equivalent to the dodge and burn tools of chemical darkrooms. As a result, you will find you need to spend far less time jumping between the two programs. (For more information, see page 155.)

Better Lightroom-Photoshop integration: Bouncing between editing a photo in Lightroom and in Photoshop is routine

for digital photographers. But in the past, it inevitably generated multiple versions of the same photo, often with different file names, that were a headache to keep straight. When you do need to move between Lightroom and Photoshop, you'll find that such round-trip editing is now simpler and much tidier. You can take any photo in your Lightroom catalog and jump directly to Photoshop, make edits, and save it back to the catalog where it appears right next to the original. Merging multiple photos into a single panorama with Photoshop can be triggered by a simple drop-down menu in Lightroom. (For more information, see page 208.)

Multiple monitor support: Lightroom 2 offers the ability to work with two windows to greatly speed the job of organizing and developing images. For example, you can use a grid view of thumbnail images on one monitor to get an overview of your images, and use a zoomed-in view on a second monitor to quickly inspect the details of a single image. (For more information, see page 44.)

Print picture packages: The ability to print different-sized photos on the same sheet of paper may not seem like a big deal. But if you are a school or wedding photographer, this is a very welcome change. Lightroom now even has an auto-layout feature that can rearrange a multiple-picture package to use the least number of pages possible. (For more information, see page 189.)

Plug-in extensions: It's now much easier for third-party software developers to create add-on programs for Lightroom. Some of the plug-ins currently available include Web gallery templates and scripts for posting your photos directly to Flickr or Facebook. Over time, the offerings are expected to greatly increase. (For more information, see pages 181 and 205.)

WHAT'S NEW IN LIGHTROOM 2?

Using This Book

Like all of Peachpit's Visual QuickStart Guides, this book uses lots of screenshots to guide you step by step through the entire process of importing, organizing, and adjusting your photos within Lightroom. Succinct captions explain Lightroom's major functions and options. Ideally, you should be able to quickly locate what you need by scanning the page tabs, illustrations, and captions. Once you find a relevant topic, dig into the text for the details. Sidebars, which run in a light-blue box, highlight the details of a particular topic, such as how previews affect your import speed or the need to calibrate your monitor.

Windows and Mac: For the most part, Lightroom's features are available for both computing platforms. Where there are differences, the **W** symbol indicates a Windows-only feature; the **M** symbol indicates a Mac-only feature. Throughout the book when keyboard-based shortcuts are shown, the Windows command is listed first, followed by the Mac command: (Ctrl-O/Cmd-O). By the way, you can see Lightroom's list of keyboard shortcuts within the program by pressing Ctrl-/ (forward slash) in Windows or Cmd-/ (forward slash) on the Mac.

This book's companion Web site (www. waywest.net/lightroom) has example photos from the book that you can download to work through many of the tasks step by step. The site also will feature tips on how to get the most from Lightroom. Feel free to write me at books@waywest.net with your own tips—or any mistakes you may find.

LIGHTROOM 2
OVERVIEW

Welcome to Adobe Photoshop Lightroom, one of the best programs available for organizing, correcting, and displaying your digital photos. Designed specifically for photographers, Lightroom combines the power of the original Adobe Photoshop with a brand-new interface that makes it easier than ever to tap that power. Lightroom also makes it a snap to import, sort, and track the flood of images that can so quickly overwhelm digital photographers.

Later chapters dive into the details. This one offers a quick tour of the Lightroom interface (**Figure 1.1**) and the major tools included in its five modules. Those five modules— Library, Develop, Slideshow, Print, and Web—give you easy access to everything you need when working with photos. Lightroom presents the modules in that order because it reflects a natural workflow, that is, the most efficient sequence of actions for working with your photos.

Left Panel Group
Content changes with
module; includes
Navigator, previews,
and preset choices

Main toolbar
Tools change as module
or view is changed

Main Lightroom
window

Module Picker
Click to switch
among five modules

Right Panel Group
Content changes
with module;
displays tools for
current module

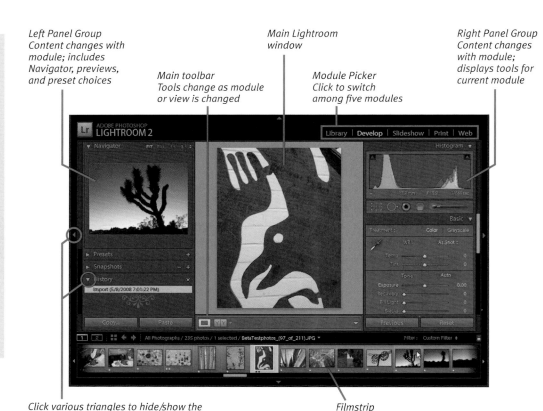

Click various triangles to hide/show the
Module Picker, Filmstrip, the two panel
groups, or the panels within

Filmstrip
Shows photos in the Library; click photo(s) in
strip to display in main Lightroom window

Figure 1.1 Lightroom works and looks virtually the same whether you're running Mac OS X, Windows XP, or Windows Vista.

Library Module

The Library module is where you import new photos; apply keywords (tags) to them; sort, rate, and label them; and mark the keepers or delete the stinkers. It has two views: Grid and Loupe (**Figure 1.2**). Grid view lets you see multiple images at once; use the Thumbnails slider to vary their size. Loupe view lets you zoom in on a single photo. (For more information, see page 39.)

Left Panel Group
Controls what photos
appear

Library Filter toolbar
Use to find photos by
variety of criteria

Right Panel Group
Controls settings for
photos selected

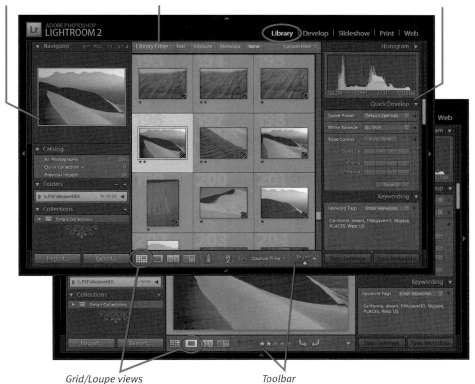

Grid/Loupe views
Click to see thumbnails of multiple
photos or zoom in on single photo

Toolbar
Choices change with module; in Library module,
buttons help you compare, sort, rate, and flag photos

Figure 1.2 Whether in Grid (top) or Loupe (bottom) view, the Library module offers panels and tools for organizing your photos.

The Left Panel Group in the Library module—and all the panels within it—control what you see in the main window (**Figure 1.3**). At the top, the Navigator helps you quickly move around within an enlarged photo displayed in the main window. The Catalog panel enables you to see all the photos in the current catalog, a smaller collection you've created, or just the most recently imported photos. The Folders panel shows you where the original master photos are stored on your computer or external hard drive. Use the Collections panel to create multiple "albums" of photos based on various criteria of your choosing. This gives you tremendous flexibility— without crowding your hard drive with duplicates of each master photo. (For more information, see page 26.)

The Library module's Right Panel Group includes so many panels that you'll either need to use the triangles to collapse some of them or be willing to use the scrollbar to reach the lower panels. At the top, the Histogram panel displays a simple graphic that contains a tremendous amount of at-a-glance information about the selected photo. For minor fixes to a photo, you can use the Quick Develop panel, and the changes will appear immediately in the Histogram panel (**Figure 1.4**). (For more information, see page 124.)

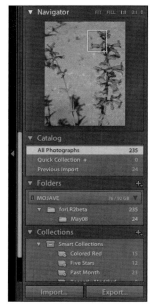

Figure 1.3
The Left Panel Group in the Library module—and all its panels—control what you see in the main window.

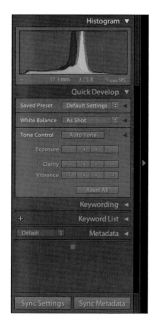

Figure 1.4
At the top of the Right Panel Group, the Histogram and Quick Develop panels help you adjust exposures without leaving the Library module.

LIBRARY MODULE

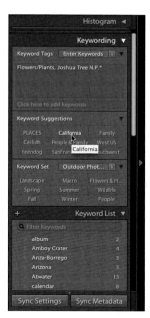

Figure 1.5
Near the bottom of
the Library module's
Right Panel Group,
the Keywording
panel helps you
attach keywords to
photos.

You'll spend lots of time in the Library module's Keywording panel since it enables you to attach multiple keywords—sometimes called tags—to a single photo or a group of photos (**Figure 1.5**). Not only does it suggest keywords based on your past choices, but it also helps you create sets of keywords that you can activate depending on the photos you're organizing. Outdoor Photography and Wedding Photography are two of Lightroom's built-in keyword sets. The Keyword List panel makes it much easier to find a few photos among thousands by helping you selectively filter the photos displayed within the main window.

Develop Module

The Develop module is where you make most of your adjustments to the selected photo's appearance (**Figure 1.6**). As in other modules, the Navigator sits at the top of the Left Panel Group and helps you move around within an enlarged photo. It also offers a preview of the effect of any of Lightroom's Presets simply by rolling your cursor over any item in the list. The Detail panel, new in version 2, gives you an up-close view while still leaving a zoomed-out view in the main window, essential for seeing the effects of sharpening and noise reduction.

Presets
Roll cursor over preset to preview in Navigator

Develop Module
Highlighted in Module Picker

Histogram
Updates in real time as adjustments applied

Tool Strip
Five tools let you crop, fix spots or red eye, apply gradient or brush adjustments.

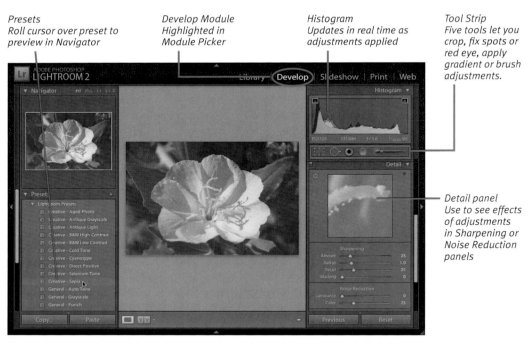

Detail panel
Use to see effects of adjustments in Sharpening or Noise Reduction panels

Figure 1.6 The Develop module is where you make most adjustments to the selected photo.

DEVELOP MODULE

Near the bottom of the Left Panel Group, the History panel tracks changes to a photo—enabling you to step back to an earlier point if you change your mind about some adjustment you make (**Figure 1.7**). The Right Panel Group contains eight different development panels, giving you a wide array of tools to fine tune your photos (**Figure 1.8**). The various sliders in the Basic panel control the bulk of Lightroom's exposure and color settings (**Figure 1.9**). (For more information, see page 136.)

Figure 1.7
Use the History panel near the bottom of the Left Panel Group to keep track of how you've changed a photo's appearance.

DEVELOP **M**ODULE

Figure 1.8
The Right Panel Group contains eight different development panels to fine tune your photos.

Figure 1.9 The various sliders in the Basic panel control the bulk of Lightroom's exposure and color settings.

Slideshow Module

Once you've picked a group of photos and adjusted their exposures, the Slideshow module helps you assemble them for an onscreen presentation (**Figure 1.10**). Using the included templates, you can quickly set the background, borders, and caption placement for the slides. You can also create your own custom layouts. (For more information, see "Using the Slideshow Module" on page 169.)

SLIDESHOW MODULE

Roll cursor over templates to preview other styling choices

Main window shows Right Panel Group slide choices

Right Panel Group Panels for setting presentation borders, layout, backdrop, titles, and soundtrack

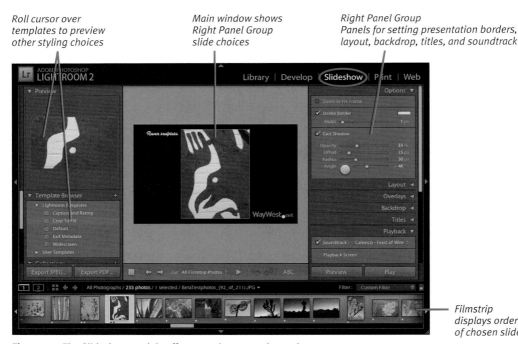

Filmstrip displays order of chosen slides

Figure 1.10 The Slideshow module offers complete control over the onscreen appearance, titling, and playback of your photo sequence.

Print Module

The Print module rounds up the sometimes-scattered settings you need to fine tune photo prints: page layout, printer settings, color profiles, sharpening tailored to the final print size, and more (**Figure 1.11**). Again, Lightroom gives you the choice of using layout templates or building your own. (For more information, see "Making Prints" on page 187.)

Roll cursor over templates to see print layouts in Preview panel

Main window shows how selected prints flow on page

Right Panel Group choices set borders, rulers, and size-based sharpening

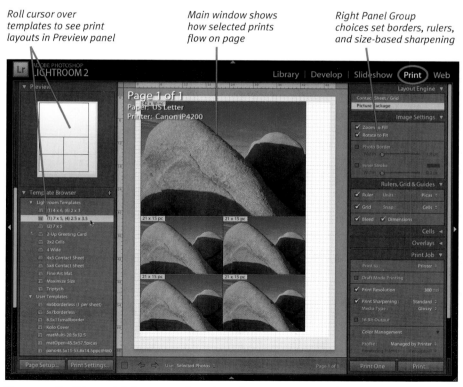

Figure 1.11 The Print module lets you set how photos lay out on a page, and there are controls to adjust the amount of sharpening applied to various print sizes.

Web Module

The Web module makes it incredibly simple to assemble a group of photos and prepare them for display on a Web site (**Figure 1.12**). It includes a variety of layout templates or you can create custom ones of your own. Once you pick a layout, Lightroom can quickly generate all the thumbnails and coding needed to display the photos in HTML or in the Adobe Flash format. You can then upload the results from the module directly to your Web site. (For more information, see "Creating Web Galleries" on page 180.)

WEB MODULE

Main window shows how album & buttons appear on Web site

Engine panel shows whether template based on Adobe Flash, HTML, or third-party package

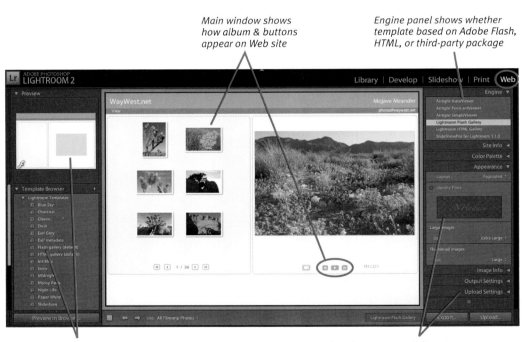

Choices depend on Engine selection in Right Panel Group

Other choices control album's appearance, colors, titles or caption, and upload settings

Figure 1.12 Lightroom's Web module can build photo layouts, generate the needed HTML or Flash coding, and upload them to your Web site.

Figure 1.13 These four triangles control when you see the Module Picker, the Right Panel Group, the Filmstrip, and the Left Panel Group.

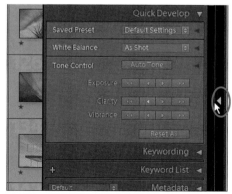

Figure 1.14 Oops: The default action triangles make it easy to reach for a scroll bar (top) and, instead, trigger a panel to appear (bottom).

Controlling Triangle Actions

Four areas surround Lightroom's main window: the Module Picker, the Right Panel Group, the Filmstrip, and the Left Panel Group. When and how they appear is controlled by four triangles sitting at the center of the top, right, bottom, and left boundaries (**Figure 1.13**). By default, these four areas appear and disappear whenever you roll your cursor onto or off of one of these triangles. Lightroom calls it Auto Hide & Show. (This does not happen with any of the individual panels within the panel groups, just these four.) The problem is that it's easy to accidentally trigger this behavior by, for example, trying to scroll through your main window (**Figure 1.14**). Avoid the problem by changing the default action for each triangle.

To change the triangle action:

1. Right-click any one of the four triangles along Lightroom's outside edge (**Figure 1.15**). (Control-click on Macs with a single-button mouse.)

2. Choose Manual from the drop-down menu and the new action is applied. This setting requires you to deliberately click the triangle to show or hide the panel.

3. Repeat steps 1–2 to change the setting for the remaining three triangles.

✔ Tip

- In step 2, in addition to choosing one of the top three actions, you also can choose Sync with Opposite Panel. This applies this panel's action settings to the panel on the other side of the main window (Module Picker and Filmstrip, or Left Panel Group and Right Panel Group) (**Figure 1.16**). Whether it helps you to apply this option to either pair of panels will depend on your work style.

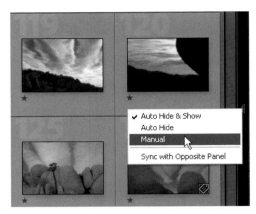

Figure 1.15 Right-click any one of the four triangles, and choose **Manual** to change the triangle's default action.

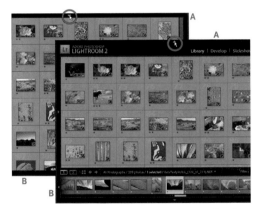

Figure 1.16 With the top triangle set to Manual and Sync with Opposite Panel, a click hides or shows both the Module Picker (A) and Filmstrip (B).

CONTROLLING TRIANGLE ACTIONS

IMPORTING IMAGES

When you import images into Lightroom (**Figure 2.1**), the program automatically stores all the information about them in what it calls a catalog, which is basically a database. Keywords, development adjustments, preview settings—and lots more—are stored in the catalog. The beauty of this approach is that it leaves your actual images untouched. That allows you to step back in time to any previous point with any image you desire. That's a major difference from Adobe Photoshop, which dumps the History settings once you save the image. (For more information, see "Using Catalogs" on page 26.)

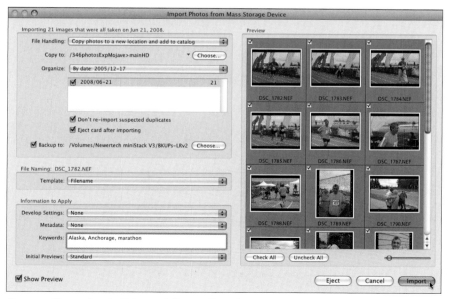

Figure 2.1 The settings in Lightroom's import dialog box enable you to control what happens to photos during the import.

Set Import Preferences

Before you start importing photos from your camera, you may want to change how your computer responds when you connect the camera or insert a memory card of photos. The process differs on Macs and Windows machines, but both platforms usually try to take over the import process using programs other than Lightroom. Instead, you want to make Lightroom your main way of moving photos into your computer, which you can do only *after* you've installed Lightroom 2.

To set Lightroom to import photos:

1. By default, PCs are set up to import your photos using Windows XP or Windows Vista. When you connect your digital camera or memory card, the AutoPlay dialog box appears (**Figure 2.2**).

2. Click the bottom choice—Set AutoPlay defaults in Control Panel—to open the AutoPlay dialog box.

3. In the Pictures drop-down menu, choose Import photos using Adobe Photoshop Lightroom 2.0 and click Save to apply the setting (**Figure 2.3**).

4. To confirm that the setting is active, choose Edit > Preferences and click the Import tab. The first check box—Show import dialog box when memory card is detected—is now selected (**Figure 2.4**). None of the other settings here needs to be changed, so click OK to close the dialog box. From now on, when you connect a digital camera or memory card, AutoPlay offers you the choice to import photos using Lightroom (**Figure 2.5**).

✔ Tip

■ If you do not want *any* program to start up when you connect the camera or memory card, then in step 3 choose Take no action in the drop-down menu.

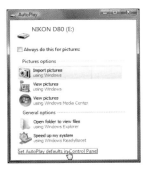

Figure 2.2
When the AutoPlay dialog box appears, click the bottom choice to set what happens when you connect your camera or memory card.

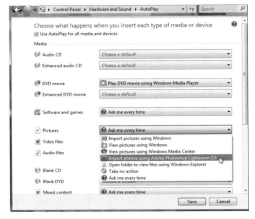

Figure 2.3 In the Pictures drop-down menu, choose Import photos using **Adobe Photoshop Lightroom 2.0** and click Save.

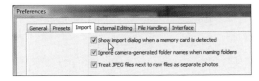

Figure 2.4 The Import tab confirms that Lightroom's import dialog box will appear automatically.

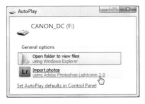

Figure 2.5
AutoPlay now offers you the choice to import photos using Lightroom.

SET IMPORT PREFERENCES

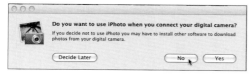

Figure 2.6 On most Macs, iPhoto automatically asks to import your photos. Select No to stop the process.

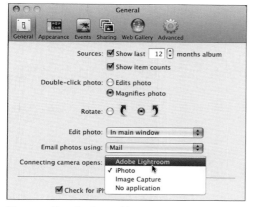

Figure 2.7 Use the General button in iPhoto's Preferences dialog box to choose Adobe Lightroom instead of iPhoto.

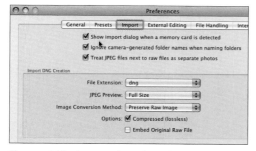

Figure 2.8 The Import tab confirms that Lightroom's import dialog box will appear automatically.

Ⓜ To set Lightroom to import photos:

1. Most Macs come with iPhoto already installed and, by default, iPhoto automatically starts up and asks to import your photos when you connect a digital camera or memory card (**Figure 2.6**). If this dialog box appears, select **No** to stop the auto import process and close the dialog box.

2. Launch iPhoto and from the Menu bar, choose iPhoto > Preferences. Click the General button in the Preferences dialog box, and from the Connecting camera opens drop-down menu, choose Adobe Lightroom (**Figure 2.7**). Click the upper-left red button to close the dialog box and the change is applied.

3. To confirm that the setting is active, choose Lightroom > Preferences and click the Import tab. The first checkbox—Show import dialog box when a memory card is detected—is now selected (**Figure 2.8**). Click the upper-left red button to close the dialog box. From now on, when you connect a digital camera or memory card, Lightroom's import dialog box automatically appears.

✔ Tip

■ If you do not want *any* program (including iPhoto and Lightroom) to start up when you connect the camera or memory card, then in step 2 choose No application in the drop-down menu, and click the upper-left red button to close the dialog box.

Importing Images

If you've already set up Lightroom to capture imported images—as explained in the previous section—the import dialog box appears when you connect your digital camera or memory card, so skip to step 2 below. However, you also can manually trigger an import as explained below in step 1. If you already have a catalog of images that you want to import, perhaps from Lightroom's first version, see "To import a Lightroom version 1 catalog" on page 27.

No matter which method you use, the first time you import images, you'll need to make a number of decisions about the process. Once you choose your settings, however, future imports don't take much time because Lightroom will use those same settings.

To import images:

1. In the Library module, click the **Import** button in the lower-left corner (**Figure 2.9**).

 or

 From the Menu bar, choose File > Import Photos from Disk and navigate to the images you want on one of your hard drives. If you want to import every image in a folder, select it and choose Import All Photos in Selected Folder, or select individual photos within a folder and click Choose (**Figure 2.10**).

 or

 Navigate to a folder or individual images, select them, and drag them into the Grid view of the Library module (**Figure 2.11**).

Figure 2.9 One of three ways to start importing: Click the Import button in the Library module.

Figure 2.10 To import *every* image in a folder, select it and choose **Import All Photos in Selected Folder** (top), or you can select *individual* photos within a folder and click **Choose** (bottom).

Figure 2.11 You also can select and drag images directly into the Library's Grid view.

Figure 2.12 Use the thumbnail check boxes to deselect images you do *not* want imported.

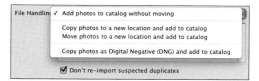

Figure 2.13 The import dialog box's File Handling drop-down menu lets you choose how to copy or move images.

Auto Import

Lightroom's Auto Import settings are useful mainly if you work in a studio doing what's called *tethered shooting*, where your camera is connected to your computer while you shoot. If your camera offers the capability, like Canon's Remote Capture or Nikon's Capture Control Pro, you can designate a folder on your computer that Lightroom watches for any new files. When they appear, Lightroom automatically imports them, making it easy to inspect the shots on your computer monitor instead of on the camera's tiny LCD. To set up Lightroom's part, choose File > Auto Import > Auto Import Settings.

2. The import dialog box appears, with thumbnails on the right of the images to be imported. Use the thumbnails' check boxes to deselect images you do not want imported (**Figure 2.12**).

3. From the File Handling drop-down menu (**Figure 2.13**), choose any of the following:

▲ **Add photos to catalog without moving**: The photos remain where they were originally. The Lightroom catalog will store any information you add, including development adjustments, and link to the original file. For that reason, the import is very fast but development settings can only be applied when the hard drive containing the originals is connected to your computer. (Keywords, labels, and metadata, however, can be added without the hard drive being connected, since that information is stored in a Lightroom catalog.) If you use this choice, skip to step 6.

▲ **Copy photos to a new location and add to catalog**: If you are importing photos from a memory card, use this option. The original photos are duplicated and moved to the hard drive where your Lightroom catalog is stored. Any metadata associated with those files (known as sidecar files) also is copied. After the import, any changes you make in Lightroom are applied to the duplicates in the new location. The originals are not changed, allowing them to serve as untouched backups. While Lightroom keeps all this perfectly straight, you need to remember the distinction to avoid getting confused since you wind up with two sets of identically named images.

(continues on next page)

▲ **Move photos to a new location and add to catalog**: Just like the name says, under this option the original photos are moved to the hard drive where your Lightroom catalog is stored. Any metadata associated with those files (known as sidecar files) also is moved. Images and sidecar files at the original location are *deleted*, which is a good reason *not* to choose this option. If you want to make a fresh start at consolidating or reorganizing all your images, it still makes more sense to choose "Copy photos to a new location and add to catalog" instead. Besides, all the moving and removing takes more time.

▲ **Copy photos as Digital Negative (DNG) and add to catalog**: Pay this no mind if your camera only shoots JPEGs and does not support digital raw capture. If your camera can produce raw files, select this choice only if you're familiar with the pro and con arguments of this hotly debated choice. (See "Raw vs. DNG" sidebar.)

4. If you are moving or copying the originals, click the Choose button to navigate to the hard drive/folder where they will be stored. You can store them on an external hard drive or your computer's internal drive (see "Laptop Drive Quandary" on page 25.) Adobe recommends, however, that they *not* be stored on a networked drive.

Raw vs. DNG

Raw camera files do not come in a single file format. Instead, various camera makers support different proprietary formats: Canon uses .CRW and .CR2, Nikon has .NEF, and so on. There's no way of knowing which of these formats will survive the test of time—and market share. That makes some photographers nervous: Will you even be able to open those files a decade from now?

Hence DNG, created by Adobe but based on open source code, which means its workings aren't hidden behind a patent wall. It's a young format, however, and some photographers warn that there's no guarantee about its long-term survival either.

Fortunately, there is a way to keep both options open. When importing photos, in step 3 (on the previous page) choose "Copy photos as Digital Negative (DNG) and add to catalog." Then in step 7 (page 20) be sure to select "Backup to" and choose an external drive to store your original raw files. After importing your photos, any changes you apply in Lightroom are applied only to the DNG files. The raw files remain safe for the future—assuming you hang on to that growing pile of hard drives.

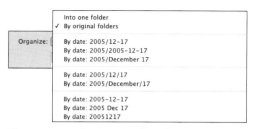

Figure 2.14 Use the Organize drop-down menu to set how the folders and subfolders are named.

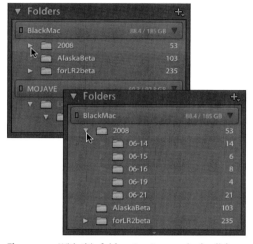

Figure 2.15 With this folder structure, a single click expands or collapses an entire year in the Library module's Folders panel.

Figure 2.16 Select the Backup to check box to make an immediate, one-time backup before the photos are imported.

5. From the **Organize** drop-down menu (**Figure 2.14**), choose any of the following:

 ▲ **Into one folder**: As the name suggests, this moves all the photos into a single folder. Useful if you're moving photos from a memory card or reorganizing a set of previously used folders.

 ▲ **By original folders**: This preserves the folders and subfolders used to store the original images. Useful if you've already created a set of folders with specific names (such as locations) that help you stay organized.

 ▲ **By date**: Creates and names the new folder based on the date the photos were shot. I use the 2005/12-17 structure because, once back in the Library module, a single click can expand or collapse a year's worth of folders (**Figure 2.15**). (The 2005/December/17 choice would do the same by year and month.)

6. Select the check boxes for Don't re-import suspected duplicates and Eject card after importing. Also select the Backup to check box and click Choose (**Figure 2.16**).

(continues on next page)

IMPORTING IMAGES

7. Navigate to where you want to store an immediate, one-time backup of the imported photos—before any changes are applied within Lightroom. It's best to choose another hard drive to guard against the failure of your primary drive (**Figure 2.17**). When the import dialog box reappears, it lists the selected backup destination (**Figure 2.18**). (Also see the first Tip on page 24.)

8. In the File Naming section, make a choice using the Template drop-down menu (**Figure 2.19**). (Also see the second Tip on page 24.) The File Naming line example changes as you change the settings—as long as you tab out of the Custom Text and Start Number fields (**Figure 2.20**).

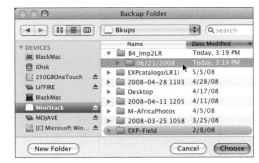

Figure 2.17 Choose another hard drive for the backup to guard against failure of your primary drive.

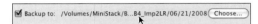

Figure 2.18 When the import dialog box reappears, it lists the selected backup destination.

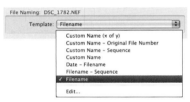

Figure 2.19 In the File Naming section, make a choice using the Template drop-down menu.

Figure 2.20 Once you tab out of the Custom Text and Start Number fields, the File Naming line example reflects the new naming scheme.

IMPORTING IMAGES

Figure 2.21 The Develop Settings let you apply a change to all the imported photos. However, it's more flexible to do this in the Develop module after the import.

Figure 2.22 Though usually set to None, you can use the Metadata drop-down menu to apply metadata during the import.

Figure 2.23 Use the New Metadata Preset dialog box to enter information you want applied to *all* the imported photos, such as a copyright notice.

9. In the Information to Apply section, use the Develop Settings drop-down menu if you want to apply a particular setting to all the imported photos (**Figure 2.21**). Generally, it's more flexible to do this after import, using the Develop module. But it can save you time if, for example, you definitely want to make all the photos look like old-fashioned sepia-tone photos. (For more information, see "Using the Presets Panel" on page 131.)

10. Also in the Information to Apply section, **you can use the Metadata drop-down** menu to create or apply metadata to the imported photos (**Figure 2.22**). Usually this is set to None (see the third Tip on page 24). Otherwise, choose New and use the New Metadata Preset dialog box to enter the information you want to use (**Figure 2.23**). Click Create when you're done, and then choose your new preset from the Metadata drop-down menu.

(continues on next page)

11. If all the photos you're importing are, for example, of the same subject or location, use the Keywords text window to apply them. Type a keyword into the text window, and a list of similarly spelled keywords you've used before appears. Make a selection by pressing Enter (Windows) or Return (Mac) (**Figure 2.24**). Type a comma after the keyword before entering another keyword (**Figure 2.25**).

12. The Initial Previews setting can make a big difference, depending on how you shoot (see "Previews Affect Import Speed" at right). From the Initial Previews drop-down menu (**Figure 2.26**), choose any of the following:

▲ **Minimal:** The fastest way to display *initial* previews of your photos, but it uses the camera's smallest embedded preview and so may not immediately display the colors accurately.

▲ **Embedded & Sidecar:** Uses the camera's largest embedded preview, which may not immediately display the colors accurately. Slightly slower than the Minimal preview, but faster than the other two preview choices.

▲ **Standard:** Uses previews generated by Lightroom based on the more accurate ProPhoto RGB color space.

▲ **1:1:** Uses Lightroom-generated previews that render every pixel in the image, so you can zoom in for a 1-to-1 view. However, it takes considerably longer than the other choices. Also based on the ProPhoto RGB color space.

Figure 2.24
Type in the Keywords text window and a list of similarly spelled, previously used, keywords appears.

Figure 2.25 Type a comma between each keyword that you want to apply to all the imported photos.

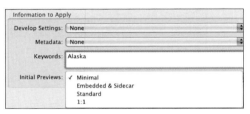

Figure 2.26 The Initial Previews setting makes a big difference in how fast the photos are processed during import.

Previews Affect Import Speed

You can control the quality of the previews that initially appear as Lightroom imports each photo. Rendering those previews directly affects how long it takes Lightroom to finish the import. If you simply need to confirm that Lightroom now has the photo so that you can get back to shooting, the Minimal or Embedded & Sidecar choices make sense. Otherwise, the Standard or 1:1 choices are better because they use Lightroom's color management.

IMPORTING IMAGES

Figure 2.27 A progress bar tracks the import and preview process.

13. Finally, double-check your settings and click Import. A progress bar tracks the import and preview process (**Figure 2.27**). Once the import finishes, an alert sounds and the card is disconnected (though not actually ejected). The Catalog panel shows the number of imported images in the Previous Import line (A) while the Folders panel shows their location and organization (B) (**Figure 2.28**). You can continue to import other images or, once you're done, begin to review and rate them in the Grid view of the Library module (see "Organizing and Reviewing Images," page 55).

(continues on next page)

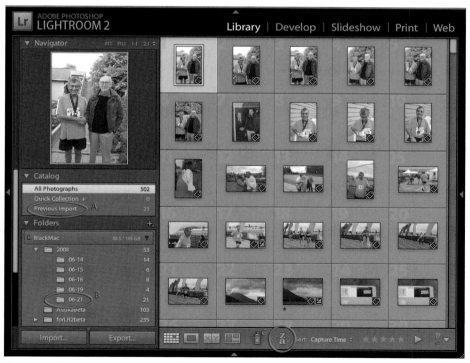

Figure 2.28 The Previous Import entry (A) in the Catalog panel shows how many images were imported, while the Folders panel shows their location and organization (B). Reversing the sort order (z-a) (C) puts the imported photos at the top of the Grid, where you see them without scrolling.

✔ Tips

- In step 7, name your backup folders so that you'll understand what's in them months later. For example, I use the date to name that import session's folder, which is stored inside a "B4_Imp2LR" folder.

- In step 8, if you choose Filename, be sure your camera is set not to start numbering individual *files* starting from the beginning every time you reformat the card. That was the default on my Nikon D-80, which created some short-term chaos in Lightroom, which kept generating the same file names repeatedly.

- In step 10, Lightroom can handle all sorts of metadata but it's best to add most of that information *after* importing photos. However, it's common to add your name or copyright during import since that's the same for every photo.

- By reversing the Grid view's sort order (z-a), imported photos appear at the top. That saves you from having to scroll down to the bottom of the window, which can be a long way down as you import more and more images (C, **Figure 2.28**).

- The Show Preview check box in the import dialog box's bottom-left corner turns on or off the thumbnail previews. It's hard, however, to imagine a circumstance where you would not want to see the thumbnails before clicking Import.

Laptop Drive Quandary

When you move or copy your originals, you'll need to decide whether to store them on an internal or external hard drive. For desktop users, the choice is academic. But photographers using laptop computers on location face some tradeoffs.

While there are lots of fast, roomy external drives for desktop machines, many laptops offer only USB connections. Though manufacturer charts may say otherwise, even USB 2.0 is generally too slow to be practical if you're making lots of changes to the 8-10 MB files of typical digital SLRs. If you can, use a compact external drive with an IEEE 1394 connection (also known as FireWire from Apple, i.Link from Sony). The choices are limited, but there are ones small enough to tote along with your laptop. And they weigh a lot less than that 200mm/f2.8 lens.

Put all the images on an internal drive, and Lightroom will enjoy relatively speedy read and write access. But sooner or later, the drive fills up and then you'll have to offload some of the images to an external drive.

If you can't bear hauling along an external drive for your laptop, consider creating "field" and "home" setups using two different Lightroom catalogs. The home setup uses one set of drives (either the machine's internal drive or fast external drives) to store all your images, while the field setup uses the laptop's internal drive. Once home from a trip, you can use Lightroom to export the laptop catalog and merge it with the desktop machine's catalog. (For more information on how to do this, see "Using Catalogs" on the next page.)

Some photographers ditch the computer entirely and use a portable photo storage driver/viewer when shooting on location. Such devices enable photographers to dump photos off their memory cards and use the tiny LCD screen to confirm that the photos transferred safely. Back home, they move the photos onto their computer, where they do their Lightroom work.

Using Catalogs

Lightroom 2 now makes it practical to keep all your images in a single catalog. That's a welcome change from the first version, which often forced photographers to spread their photos across multiple Lightroom catalogs to avoid slowdowns.

If you are upgrading from an earlier version of Lightroom, see "To import a Lightroom version 1 catalog" on the next page. If you're starting fresh with version 2, Lightroom automatically creates a new catalog the first time you import any photos, as already explained in "To import images" on page 16. As you add photos, that catalog keeps track of where the original images are stored.

While there is now less need to switch among catalogs, you may need to do so when working with existing catalogs. (For more information, see "To switch to another catalog" on page 27.) The other situation where you'll switch catalogs is when using multiple computers, such as a desktop and laptop. You sometimes can sidestep this if you store your original photos and the related Lightroom catalog on an *external* drive. That way, you can move from the desktop machine to the laptop simply by connecting the external drive to one or the other. (Adobe allows you

to install the Lightroom program on a desktop machine and your laptop.)

If you do not want to constantly carry an external drive, however, you'll need to move Lightroom catalogs by exporting and importing them. The roundtrip process sounds more complicated than it is:

◆ At home or the office, export a catalog of photos from your desktop machine if you need them on the laptop while working on location. Typically, you copy the exported catalog to the laptop using an external drive, which stays behind with the desktop machine (**Figure 2.29**).

◆ In the field, you import that catalog on the laptop. If you don't need any catalog photos from the desktop machine, you just use Lightroom on the laptop to capture new photos shot on location.

◆ Back home or at the office, you export the laptop's catalog to an external drive and import it back to the desktop machine. For the step-by-step details, see "To export photos as a catalog" on page 28 and "To import from a catalog" on page 30.

One last thing: The catalog acts as Lightroom's heart *and* brain, so you need to set up a regular schedule for backing it up. See "To set catalog backups" on page 32.

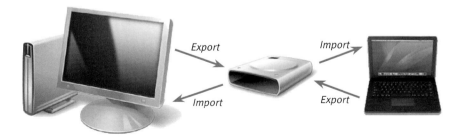

Figure 2.29 Use an external hard drive when exporting or importing catalogs from one computer to another.

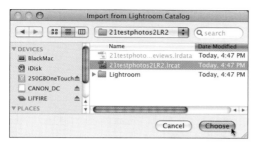

Figure 2.30 To import an existing Lightroom catalog, navigate to the file, which ends with .lrcat, and click Choose.

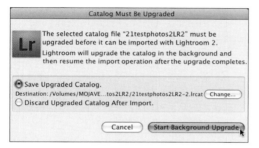

Figure 2.31 If Lightroom asks to upgrade the catalog, choose Start Background Upgrade.

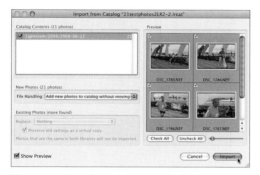

Figure 2.32 Once the catalog upgrade finishes, Lightroom's import dialog box appears. Make file handling choices before clicking Import.

Figure 2.33 Finally, a progress bar tracks importing the existing catalog's images into Lightroom.

To import a Lightroom version 1 catalog:

1. From the Menu bar, choose File > Import from Catalog.

2. Navigate to the catalog you want to import—the file name ends with .lrcat—and select Choose (**Figure 2.30**).

3. If Lightroom asks to upgrade the catalog, choose Start Background Upgrade (**Figure 2.31**). A progress bar tracks the catalog upgrade.

4. Once the upgrade is completed, Lightroom's import dialog box appears (**Figure 2.32**). Use the File Handling drop-down menu to choose how to add the photos—by copying or moving them—and choose Import. (For more information, see step 3 of "To import images" on page 17.)

5. A progress bar tracks the import process (**Figure 2.33**). When the import finishes, the photos appear in Lightroom's Library module. You now can review and rate them in the Grid view of the Library module (see "Organizing and Reviewing Images," page 55.).

To switch to another catalog:

1. From the Menu bar, choose File > Open Catalog (Ctrl-O/Cmd-O).

2. Use the dialog box to navigate to the catalog you want to use and choose Open.

3. Click Relaunch when asked by Lightroom. Lightroom closes the current catalog, relaunches, and opens the catalog selected in step 2.

✔ Tip

■ If you want to switch to a catalog you have used before, choose File > Open Recent and select it in the drop-down menu.

USING CATALOGS

Exporting a catalog

It is common to export a smaller catalog of photos from your desktop machine's main catalog so that you can work with them on a field laptop. Exporting also works in the other direction: Upon returning, you can export any edited or new photos from the laptop to an external hard drive.

To export photos as a catalog:

1. Select the photos you want to export, using the "All Photographs" choice in the Catalog panel, a listing in the Folder panel, or by manually selecting individual photos in the Filmstrip or Grid view.

2. From the Menu bar, choose File > Export As Catalog. Use the dialog box to name the exported catalog and choose where you want it exported, usually an external hard drive (**Figure 2.34**).

3. Select either of the two export checkboxes if you want to export the negative files (DNG), and select the third checkbox to include existing preview files with the export. (See Tip.)

Figure 2.34 Name the exported catalog and choose where you want it exported.

Figure 2.35 The export can take seconds for a few photos or several minutes for a larger catalog.

4. Click Export Catalog to close the dialog box and export the catalog. A progress bar tracks the export, which can take seconds for a few photos or several minutes if you're exporting 1,000-plus photos (**Figure 2.35**).

Lightroom sounds an alert when the export is finished, at which point you can switch to the laptop to import the just-exported catalog. (See "To import from a catalog" on page 30.)

✔ Tip

■ In step 3, choose "Export negative files" if you expect to change the Develop adjustments for these images on the computer where this new catalog will be opened. If you simply want to flag, rate, label, or add keywords to the photos in the Library module, you don't need the negative (master) photos, just the catalog itself. Negative files, because they are quite large, take much longer to export/import than the catalog itself, which contains only the metadata.

Importing a catalog

By importing a smaller catalog of photos into your laptop from a desktop machine, you can edit them while in the field. Importing also works in the other direction: Upon returning from the field, you can import a changed catalog back into the desktop machine, starting by copying it to an external hard drive.

To import from a catalog:

1. Before leaving home or the office, connect your secondary computer (usually a laptop) to the external drive that contains the Lightroom catalog you previously exported from your primary computer.

2. Navigate on the external hard drive to the folder that contains the exported Lightroom catalog, which ends with .lrcat, and the exported photos (**Figure 2.36**). Copy that entire folder to the desktop of your current computer. At that point, you can disconnect the external hard drive.

3. Launch Lightroom on the secondary computer and, from the Menu bar, choose File > Import from Catalog.

4. Navigate to the desktop, open the folder copied from the external drive, select the Lightroom catalog, which ends with .lrcat, and click Open/Choose.

5. Relaunch if asked by Lightroom. Lightroom closes the current catalog and relaunches.

Figure 2.36 Navigate on the external hard drive to the folder containing the exported Lightroom catalog and exported photos.

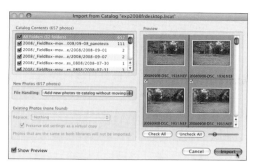

Figure 2.37 In the Import from Catalog dialog box, all the folders listed in the Catalog Contents window are checked.

6. When the Import from Catalog dialog box appears, all the folders listed in the Catalog Contents window are checked (**Figure 2.37**). Leave the File Handling pop-up menu set to "Add new photos to catalog without moving" since the photos already reside on your computer's desktop. Click Import.

 A progress bar tracks the import, which can take seconds for a few photos or several minutes if you're exporting 1,000-plus photos. When the import finishes, the imported photos appear in the Grid view. You can now work with the imported photos as needed.

✔ Tips

- Lightroom automatically spots duplicate photos in the imported catalog, such as unchanged photos already on the laptop.

- When done working with the photos on your secondary computer, you can export the catalog (and any changes in the photos). Then you can import the catalog back into your primary computer.

USING CATALOGS

To set catalog backups:

1. From the Menu bar, choose Edit > Catalog Settings (Windows) or Lightroom > Catalog Settings (Mac).

2. Select the General tab and, in the Backup section, use the pop-up menu to choose "Next time Lightroom starts only" (**Figure 2.38**).

3. Click "Relaunch and Optimize" to close the Catalog Settings dialog box and restart Lightroom.

4. Once Lightroom relaunches, the Back Up Catalog dialog box appears (top, **Figure 2.39**). Notice that the Backup Directory listed is the same hard drive on which the catalog itself is stored. If that hard drive goes bad, you not only lose the catalog but also its backups. To change that, click Choose.

5. Navigate to a different hard drive, create a folder devoted to the backup catalogs, and click Choose. When the Back Up Catalog dialog box reappears, the Backup Directory lists the changed location (bottom, **Figure 2.39**).

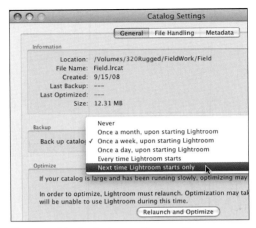

Figure 2.38 In the Backup section, use the pop-up menu to choose "Next time Lightroom starts only."

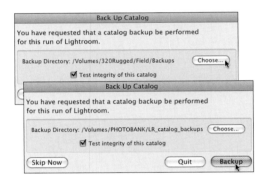

Figure 2.39 Click Choose to navigate to a backup hard drive that does not contain the catalog itself (top). Once you change the location, click Backup (bottom).

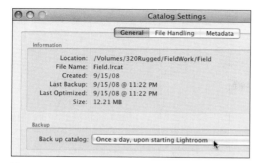

Figure 2.40 Having changed the back up location, now choose a more frequent back up interval.

6. Click Backup to close the dialog box and start the backup optimization process. Depending on the size of the catalog, it can take anywhere from a few seconds to several minutes. When the last dialog box appears, click OK to close it.

7. Once more, choose Edit > Catalog Settings (Windows) or Lightroom > Catalog Settings (Mac). Select the General tab and in the Backup section, this time use the pop-up menu to choose a shorter backup frequency (**Figure 2.40**). (See the sidebar below.)

8. Close the dialog box and Lightroom will prompt you to back up the catalog based on your choice in step 7.

Backups: When and Where?

Since Lightroom catalogs contain only metadata, they back up very quickly—usually in a few seconds. For that reason, I set the back up frequency for once a day.

As explained in "To set catalog backups," I prefer to back up to a drive other than the one on which the regular catalog is stored. If you're working on a laptop in the field, however, that means either carrying along a portable external hard drive (my choice) or clicking the Skip for Now button when Lightroom asks to back up the catalog.

Skipping a backup is fine if you are only temporarily away from your external hard drive. But if you're traveling, you could go days or weeks without performing a backup. So, again, I carry a portable hard drive—and store it separately from the laptop (back at the hotel or in another piece of luggage). Cautious or paranoid? Well, imagine how you'd feel if your laptop dies or is stolen. That sinking feeling makes a portable drive seem worth the bother.

Navigating the Library

3

The Library module is where you'll do most of your organizing and selecting of images. This chapter focuses on how to get around the Library efficiently. The following chapter, "Organizing and Reviewing Images," dives into picking, labeling, and otherwise identifying images you want to use for slides, prints, or the Web.

Using the Toolbar

Lightroom's toolbar, visible by default, runs across the bottom of the Library module's main window. If you're working on a laptop display, you may want to hide it sometimes to see more thumbnail images.

To turn off/on toolbar:

◆ From the Menu bar, choose View > Hide Toolbar. If the toolbar is hidden, choose View > Show Toolbar (**Figure 3.1**).

or

◆ Press the T on your keyboard. If the toolbar is visible, it disappears; if it's hidden, it reappears.

To set toolbar choices:

◆ Make sure the toolbar is visible and click the triangle at the right end of the toolbar. Use the pop-up menu to show or hide a particular set of tools (**Figure 3.2**). Repeat for each of the 11 choices you want to show or hide.

✔ Tips

■ While the toolbar can display up to 11 sets of items, to see them all you'd need a really wide monitor or you'd need to collapse the side panel workgroups. It's more practical to turn on just those you use regularly. My own working sets for the Library module: View Modes, Sorting, Flagging, and Thumbnail Size (**Figure 3.3**).

■ The toolbar settings can be set differently for each module. So you could turn on the Slideshow set for the Slideshow module only.

Figure 3.1
To show or hide the toolbar, choose View > Show Toolbar/Hide Toolbar. Or press the T on your keyboard to toggle it on or off.

Figure 3.2. Use the toolbar's pop-up menu to show or hide a particular tool set.

View Modes Sorting Flagging Thumbnail Size

Figure 3.3 It's more practical to turn on just the toolbar items you use regularly.

Figure 3.4
The Catalog panel gives you three choices: All Photographs, Quick Collection, or Previous Import.

Figure 3.5
The Folders panel shows all connected hard drives containing images you've already imported into the Library. Navigate to the particular folder you want displayed in the main window.

Figure 3.6
The Collections in the first sub-folder, Smart Collections, are generated automatically. Any collections you create manually are also listed.

Setting Library Source

What appears in the Library module's main window and the Filmstrip is controlled by which catalog, folder, or collection you select in the Left Panel Group. You can change the contents instantly by selecting another source among these three.

To set the Library module's photo source:

If the Left Panel Group is hidden, press Tab. In the panel group, do any of the following:

◆ Click the triangle on the left side of the Catalog panel to see a list of three default catalogs: All Photographs, Quick Collection, or Previous Import (**Figure 3.4**). Select one of the three, and the images in the main window and/or Filmstrip change to reflect your choice. (See "Creating and Using Collections" on page 107 for more information.)

◆ Click the triangle on the left side of the Folders panel to see a list of all connected hard drives containing images you've already imported into Lightroom's Library (**Figure 3.5**). Use the triangles to navigate to a particular folder of photos to display them in the main window. The images in the main window and/or Filmstrip change to reflect your choice.

◆ Click the triangle on the left side of the Collections panel to see a list of all of Lightroom's collections. The collections listed in the first sub-folder, Smart Collections, are generated automatically. Collections you've created manually are also listed. Make a selection and the images in the main window and/or Filmstrip change to reflect your choice (**Figure 3.6**). (See "Creating and Using Collections" on page 107.)

Setting the Library View

The Library module offers four basic views, each of which can be tweaked with plenty of options. The Grid view works well for getting an overview of your images. The Loupe view helps you take a closer look at a single image. Use Compare view to spot the differences between a pair of images, while the Survey view lets you inspect several images at once. (For more information on using the Compare and Survey views to winnow images, see page 74.)

To switch to Grid view:

◆ If the toolbar is visible, click the ▦ button on the far left.

 or

◆ Press the G on your keyboard.

 or

◆ From the Menu bar, choose View > Grid.

To switch to Loupe view:

◆ If the toolbar is visible, click the ▣ button on the far left.

 or

◆ Press the E on your keyboard (think E for Expanded).

 or

◆ From the Menu bar, choose View > Loupe.

To switch to Compare view:

◆ If the toolbar is visible, click the ⨉Y button on the far left.

 or

◆ Press the C on your keyboard.

 or

◆ From the Menu bar, choose View > Compare.

To switch to Survey view:

◆ If the toolbar is visible, click the ▤ button on the far left.

 or

◆ Press the N on your keyboard.

 or

◆ From the Menu bar, choose View > Survey.

Rating applied Part of Quick Collection

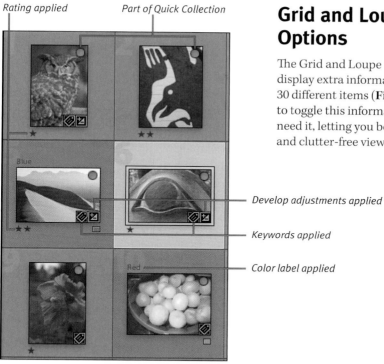

Develop adjustments applied

Keywords applied

Color label applied

Figure 3.7 Just some of the Grid view's extra information options.

Click to add/remove flag

Click to rotate left/right

Figure 3.8 To minimize visual clutter, another Grid view option enables you to display clickable buttons, such as rotate left/right, only when you roll over the image.

Grid and Loupe View Options

The Grid and Loupe views enable you to display extra information about more than 30 different items (**Figures 3.7**, **3.8**). It's easy to toggle this information on and off as you need it, letting you bounce between detailed and clutter-free views.

To set Grid view options:

1. In the Library module, from the Menu bar choose View > View Options.

 or

 Press the Shift+ J keys.

 or

 Right-click (Control-click on a Mac) any image and choose View Options in the pop-up menu (**Figure 3.9**).

2. When the Library View Options dialog box appears, click the Grid View tab (**Figure 3.10**). Select the Show Grid Extras check box and then set the remaining check boxes and drop-down menus. (For more information, see the "Grid View Options" sidebar.)

✔ Tip

■ You can control what information appears in the Filmstrip by right-clicking (Control-clicking on a Mac) a thumbnail. Choose View Options and make a choice in the pop-up menu (**Figure 3.11**).

Figure 3.9 To set Grid view options, right-click (Control-click on a Mac) any image and choose View Options.

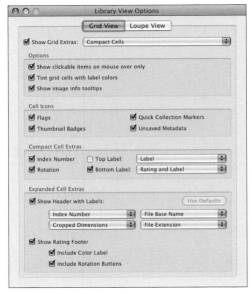

Figure 3.10 In the Grid View tab of the Library View Options dialog, select the Show Grid Extras check box and then set the remaining check boxes and drop-down menus.

Figure 3.11 To control what information appears in the Filmstrip, right-click (Control-click on a Mac) a thumbnail. Choose View Options and make a choice in the pop-up menu.

Grid View Options

Show Grid Extras is turned on by default; deselect it if you want to hide the extra information. Use the drop-down menu to choose Compact Cells or Expanded Cells. Then set the remaining check boxes and drop-down menus (**Figure 3.10**):

Options: Select which of the three options you want to appear. If you deselect Show clickable items on mouse over only, the rotate and flag buttons appear on all the thumbnails. Show image info tooltips helps you learn Lightroom's many interface items.

Cell Icons: See **Figure 3.7** to understand how the first three icons are used. The last, Unsaved Metadata, alerts you when edits have been made to an image but have not been saved back to the *original* image.

Compact Cell Extras: The Index Number is not applied to the actual photo; its display simply gives you a relative sense of where you are in a large group of photos. The Rotation buttons make it easy to correct a photo without traveling down to the toolbar. Use the Top Label and Bottom Label drop-down menus to choose from 30 information items that can be displayed (**Figure 3.12**). I prefer to apply such labels in the Loupe view to keep the thumbnails less cluttered.

Expanded Cell Extras: These choices allow each thumbnail to display up to six extra items of information. The drop-down menus offer the same 30 choices found in the Compact Cell Extras drop-down menus. All that extra information, however, means that you cannot squeeze as many thumbnails into Lightroom's main window (**Figures 3.13**, **3.14**). However, you can always press the J key to cycle from compact to expanded cells.

Figure 3.12 The Grid view drop-down menus offer 30 different information items you can display.

Figure 3.13 The Compact Cell view option shows only minimal information extras—but lets you squeeze more thumbnails into a given view.

Figure 3.14 The Expanded Cell view option offers lots of information extras, at the cost of showing fewer thumbnails in a given view.

To set Loupe view options:

1. In the Library module, from the Menu bar choose View > View Options.

2. When the Library View Options dialog box appears, click the Loupe View tab (**Figure 3.15**). Select the Show Info Overlay check box and then set the remaining check boxes and drop-down menus. (For more information, see the "Loupe View Options" sidebar.)

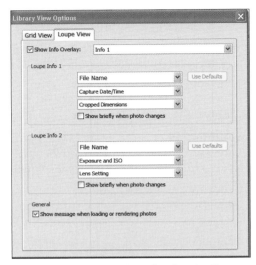

Figure 3.15 In the Loupe View tab, select the Show Info Overlay check box and then set the remaining check boxes and drop-down menus.

Loupe View Options

You can cycle through the Loupe view options—show Info 1, show Info 2, hide all extra information—by pressing the I key.

Show Info Overlay is turned on by default; deselect it if you want to hide the extra information. Use the drop-down menu to choose Info 1 or Info 2. Then set the remaining check boxes and drop-down menus (**Figure 3.15**):

Loupe Info 1: Each of the three drop-down menus offers the same 30 information choices as in the Grid View options (**Figure 3.16**). I find it useful to display exposure information in this group (**Figure 3.17**).

Loupe Info 2: As with Loupe Info 1, the drop-down menus offer 30 information choices (**Figure 3.16**). I find it useful to display caption/name information in this group (**Figure 3.18**).

General: Depending on the speed of your machine and the size of the preview being generated, Lightroom sometimes takes several seconds to display the Loupe view. If you click the check box here, Lightroom handily tells you that it's working on the preview instead of just showing a blank window (**Figure 3.18**).

Figure 3.16 Each of the Loupe view's three drop-down menus offers the same 30 information choices as in the Grid View options.

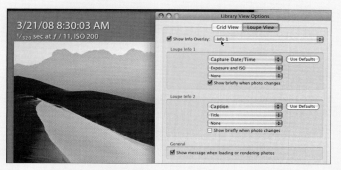

Figure 3.17 Here the Info 1 choice displays exposure-related information.

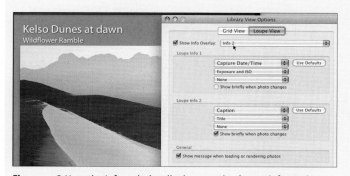

Figure 3.18 Here the Info 2 choice displays caption/name information.

Opening a Second Library Window

Lightroom 2 offers the ability to work with two windows to greatly speed the job of organizing and developing images. For example, you can use the Grid view on one monitor to get an overview of your images, and use Loupe view on a second monitor to quickly inspect the details of a single image. Or if your main monitor is more accurate color wise, use it in Develop view and use Grid view on the secondary screen. Even if you do not have a second monitor, the Loupe view still can be used to open a second window on the *same* monitor. However, that approach is useful only if you have a relatively large monitor.

To turn on a second Library window:

1. If the Filmstrip is not visible, click the small triangle at the bottom-center of Lightroom's main window. (Or press Shift-Tab to reveal the Filmstrip, then Tab again to hide the side panels.)

2. Click the Second Window button (**Figure 3.19**). By default, a second view of the Library appears in Loupe view (**Figure 3.20**).

3. If needed, adjust the placement and size of the second view by click-dragging the window's border or the bottom-right corner. Or click the Second Window button above the Filmstrip and make a choice from the pop-up menu (**Figure 3.21**).

4. To switch to a view mode other than Loupe, click Grid, Compare, or Survey in the upper-left list of views in the second window. These views work just as they do in the main window, as explained on pages 40 and 74.

Figure 3.19 In the Filmstrip, the Second Window button is dimmed when off (left) and white when on (right). If you want to turn it back off, click it again.

Figure 3.20 By default, a second view of the Library appears in Loupe view.

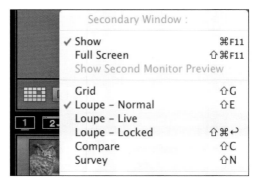

Figure 3.21 To change the second view, click the button and make a choice from the pop-up menu.

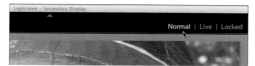

Figure 3.22 The second window's Loupe view offers three settings—Normal (the default), Live, and Locked—which control the relationship between what appears in the second window and what's selected in the first window.

Figure 3.23 With the second window set to Live, rolling the cursor over a thumbnail in the first window ...

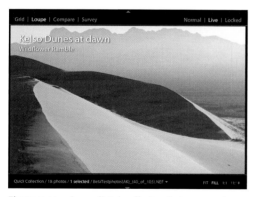

Figure 3.24 ... immediately affects what appears in the second window.

5. The second window's Loupe view offers three settings—Normal (the default), Live, and Locked (**Figure 3.22**). These settings control the relationship between what appears in the second window and what's selected in the first window:

▲ **Normal**: With this selected, the second window shows the image selected in the first window.

▲ **Live**: With this selected, the second window immediately shows the image that your cursor's hovering over in the first window's Grid or Filmstrip—even if another image is still selected (**Figures 3.23, 3.24**).

▲ **Locked**: With this selected, the second window continues to display an image even when you select another image in the first window (**Figures 3.24, 3.25**). To lock an image, right-click it (Control-click on a Mac) and choose Lock to Second Window from the drop-down menu (**Figure 3.26**).

(continues on next page)

Figure 3.25 If the second window is set to Locked, what's selected in the first window has no effect on its display.

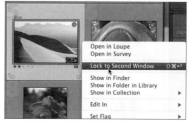

Figure 3.26 To lock an image, right-click it (Control-click on a Mac) and choose Lock to Second Window.

OPENING A SECOND LIBRARY WINDOW

6. To release the lock, click Normal or Live in the second window or right-click (Control-click on a Mac) another image in the main window and choose Lock to Second Window from the drop-down menu again. The previous image is unlocked.

or

In the Grid view of the main window, click the little Second Window button that appears on the locked image (**Figure 3.27**). The image is unlocked.

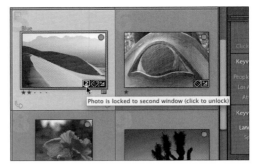

Figure 3.27 In the Grid view of the main window, click the little **2** button to unlock what appears in the second window.

✔ Tips

■ You also can use the Main Window button just above the Filmstrip to quickly switch that view to full screen, with or without the menu bar.

■ If you set the second monitor to full screen, the upper-left list of views also includes a slideshow option (**Figure 3.28**).

Figure 3.28 If you set the second window to full screen, the upper-left list of views also includes a slideshow option.

■ In step 3, you can toggle the second monitor in and out of a full-screen view by pressing Alt/Option.

■ The Second Window button retains its last view, so you can just click it the next time you want it open. Or use Shift-F11.

To turn off the second Library window:

◆ Down by the Filmstrip, click the Second Window button again. Or use your keyboard: Shift-F11.

Setting Thumbnail Size

Depending on what you're doing, you can fine-tune the size of the thumbnails to suit the task. For example, to quickly find all your obvious duds—lens cap on, flash failed to fire, so on—you might zoom out to look over as many images as possible. To get a better sense of your best shots, you'd want to zoom in enough to actually see some details of the images.

To set thumbnail size:

◆ If the toolbar is visible, drag the Thumbnails slider to change the size of the images.

 or

◆ If your keyboard has a numerical pad, press the - (minus) or + (plus) key to zoom out or zoom in on the thumbnails.

SETTING THUMBNAIL SIZE

Setting Sort View

Lightroom offers 12 ways to sort your view of images in the Library module. Since it's easy to switch from one to another, you can pick the sort view that works best for a particular task. When you first review a batch of newly imported images, for example, sorting by reverse order of capture time puts the most recent images at the top where you can see them immediately.

To set sorting:

◆ Click the Sort pop-up menu to pick the type of sort applied to the main window (**Figure 3.29**). Click the a-z button just left of the Sort menu to set the sort order (descending or ascending).

Figure 3.29 Click the Sort pop-up menu to pick the type of sort applied to the main window.

Figure 3.30 Drag a photo to another spot in the Grid. The thin vertical line between the existing images becomes bold black, marking the selected photo's destination.

Figure 3.31 Release the cursor and the selected photo moves to its new spot in the Grid.

Figure 3.32 A stack of mini-thumbnails signals that you are moving more than one image.

Rearranging Photos

You can easily rearrange photos in the Grid view if that makes it easier to compare or organize them. The shuffling doesn't change the photos, just your view of them.

To rearrange photos:

1. Click to select a photo you want to move. Its surrounding frame lightens.

2. Click again in the center of the photo and drag it to another spot in the grid. The thin vertical line between the existing images becomes a bolder black, marking the selected photo's destination. A mini-thumbnail of the selected image also appears (**Figure 3.30**).

3. Release the cursor and the selected photo moves to its new spot in the Grid (**Figure 3.31**).

✔ Tip

■ You also can select multiple images and drag them to a new place in the grid. A stack of mini-thumbnails signals that you've selected more than one image (**Figure 3.32**). The selected images do not need to be next each other, though they will be once moved (**Figure 3.33**).

Figure 3.33 The selected images, which may have not been next to each other before the move, are grouped together afterward.

REARRANGING PHOTOS

Moving Through Photos

Lightroom offers several ways to move among the images in the Library's main window: forward or back one image at a time, from screen to screen, or to the top or bottom of the window.

To move from photo to photo:

In any view (Grid, Loupe, Compare, or Survey), do one of the following:

◆ Press the keyboard's left/right arrow keys to move back or forward one photo at a time.

◆ If Navigate is turned on in the toolbar drop-down menu, use the previous or next buttons to move to another image (**Figure 3.34**).

✔ Tips

■ In the Grid view, you also can press the up/down arrow keys to move to the image above or below the current image.

■ When working in the Loupe view, you can keep a sense of your place in the image sequence by turning on the Filmstrip (Shift-Tab, then Tab again to hide the side panels) (**Figure 3.35**).

Figure 3.34 If the Navigate buttons are turned on in the toolbar, you can use them to move to another image.

Figure 3.35 When working in the Loupe view, the Filmstrip helps you keep a sense of where you are in the overall image sequence.

To move from screen to screen:

◆ In the Grid or Loupe view, press the Page Up/Page Down keys. The Library's main window changes to display a new screen of images (in Grid) or a new single image (in Loupe).

or

Scroll through the Filmstrip to find another image, click its thumbnail, and the Library's main window displays that selection.

To move to top or bottom of the Grid:

◆ In the Grid view only, you can jump to the top of the thumbnails by pressing the Home key. Or move to the very bottom of the thumbnails by pressing the End key.

MOVING THROUGH PHOTOS

Selecting Images

Lightroom offers several ways to select one image, a group of adjacent images, or multiple images not next to each other. Once selected, you can apply the same action to all those images.

To select an image:

◆ In the Grid view, roll the cursor over an image you want to select, and click. The image is selected, as indicated by its surrounding frame becoming lighter than the other images (**Figure 3.36**).

To select multiple images:

1. Click your cursor on the first image you want to select in the Grid view.

2. Press and hold Ctrl (Windows) or Cmd (Macintosh) while clicking each of the other images you want to select. The surrounding frame of each selected image lightens (**Figure 3.37**).

 or

 If all the images you want are in a row, press Shift and click the last image in the group. The surrounding frames lighten for all the images between the first and last clicked images (**Figure 3.38**).

✔ Tips

■ When you select multiple images, the surrounding frame for the one selected *first* is brighter than the rest (**Figure 3.37**).

■ To select all the images in the Grid, press (Ctrl-A/Cmd-A). The surrounding frames for all the images lighten, indicating that they are selected.

■ To deselect an image in the Grid, press the / key. If multiple images are selected, they are deselected one at a time as you continue pressing the / key.

Figure 3.36 The frame of a selected image is lighter than those of the other images.

Figure 3.37 To select multiple images, press and hold Ctrl (Windows) or Cmd (Macintosh) while clicking the other images you want.

Figure 3.38 If all the images you want are in a row, just press Shift and click the last image in the group to select them all.

Figure 3.39 To rotate an image, click one of the two arrows at the bottom corners.

Figure 3.40 You also can rotate selected images by right-clicking them (Control-clicking on a Mac) and choosing Rotate Left or Rotate Right.

Figure 3.41 If the two rotate arrows are turned on in your toolbar, click the one you need.

Rotating Images

Most digital cameras now do this automatically, but manually rotating images may still be necessary, especially with scanned images. While rotating images arguably belongs in the Developing Images chapter, you're more likely to notice unrotated images at this stage, so I've put it here.

To rotate an image:

Select the image(s) you want to rotate in the same direction and do any of the following:

◆ Roll the cursor over any of the selected images and click one of the two arrows at the bottom corners to rotate the image clockwise or counterclockwise. The images rotate in the selected direction (**Figure 3.39**).

◆ Right-click (Control-click on a Mac) any of the selected images and choose Rotate Left or Rotate Right from the drop-down menu (**Figure 3.40**). The images rotate in the selected direction.

◆ If the two rotate arrows are turned on in your toolbar, click the one you need (**Figure 3.41**). The images rotate in the selected direction.

✔ Tip

■ To deselect an image you've selected in the Grid view, press the / key. If multiple images are selected, they are deselected one at a time as you continue pressing the / key.

ROTATING IMAGES

ORGANIZING AND REVIEWING IMAGES

4

You'll do most of your organizing and reviewing of images in the Library module. Along with the catalog database discussed in Chapter 2, the Library module is what gives Lightroom an edge over its more well-known cousin, Photoshop. Both give you vast photographic powers, but Lightroom's Library module offers the most efficient way to pick, label, rate, and otherwise identify individual photos amid the incoming digital flood.

It's tempting to jump ahead to the Develop module and immediately start fixing and tweaking the exposures of your photos. After all, it can be a bit of a slog combing through your images, comparing one against another, and making the judgments about which ones to keep and which to reject. But the time spent offers a hidden bonus: deleting poor images (explained on page 79) will leave you with far fewer—and much better—images once you finally turn to adjusting their exposures.

Adjusting Your Review Setup

Before diving into reviewing your photos, you may want to know about two very helpful Lightroom options: dimming the lights and stacking photos. Together they can make a big difference in helping you concentrate on your photos—and their sometimes subtle differences.

The "lights out" feature lets you dim or hide every part of the Lightroom interface except the photos. The stacking feature lets you gather a bunch of similar images and "stack" them, much as you might bunch up slides on an old light table to concentrate on the remaining photos. You can even automatically stack photos, which is particularly useful for tidying up contiguous, same-subject photos such as bursts of motor-drive shots, panorama sequences, or bracketed HDR (High Dynamic Range) exposures.

To dim or turn off the lights:

1. Select the photos on which you want to concentrate (**Figure 4.1**). In any module:

 ▲ In the Menu bar, choose Window > Lights Out and Lights Dim or Lights Off.

 or

 ▲ Press the L on your keyboard once (to dim) or twice (to turn lights off).

2. Depending on your choice, the surrounding Lightroom interface dims by 80 percent or darkens completely (**Figures 4.2, 4.3**).

✔ Tip

■ To jump directly from lights on to lights dimmed without having to cycle through all three settings, press Shift-Ctrl-L/Shift-Cmd-L. Repeat to jump directly back to lights on.

Figure 4.1 Select the photos you want to focus on once the lights are dimmed.

Figure 4.2 By default, the lights dimmed choice darkens the Lightroom interface by 80 percent. You can adjust the amount of dimming.

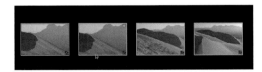

Figure 4.3 The lights-out choice hides every bit of Lightroom except the selected photos.

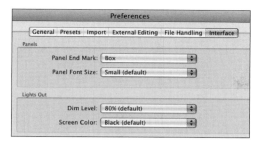

Figure 4.4 Use the Dim Level drop-down menu to adjust the dimming effect by 50 to 90 percent. Screen Color choices range from pure black to pure white.

To cycle through the lights settings:

◆ In any module, press the L on your keyboard up to three times to go from lights on to lights dimmed to lights off, and back to lights on.

To change the lights setting:

1. In any module, press Ctrl-, /Cmd-, (comma) and click the Interface tab in the Preferences dialog box.

2. In the Lights Out panel, use the Dim Level drop-down menu to set the dimming effect between 50 and 90 percent (the default is 80 percent) (**Figure 4.4**).

3. In the same panel, the Screen Color drop-down menu lets you choose among several colors other than black if you find that default not to your liking (including white, simulating photos on a blank page).

4. To apply the settings and close the dialog box, click OK.

ADJUSTING YOUR REVIEW SETUP

To stack/unstack images:

1. In the Filmstrip or Grid view, select the photos you want to stack (**Figure 4.5**).

2. Right-click (Control-click on a Mac) one of the selected images and in the pop-up menu, choose Stacking > Group into Stack (**Figure 4.6**). The selected photos are rearranged as one photo with a small number showing how many photos the stack contains (**Figure 4.7**).

3. To unstack a group of photos, right-click (Control-click on a Mac) the number atop the stack and choose Unstack in the pop-up menu (**Figure 4.8**). The stack disappears, replaced by all the photos previously in the stack.

✔ Tips

■ Don't confuse unstacking a stack with expanding it. Unstacking dismantles the stack, while expanding simply reveals all the photos contained in the stack.

■ You cannot create a stack while working within a collection, only by selecting "All Photographs" in the Catalog panel or by selecting a hard drive or folder in the Folders panel. If you try to stack images while working inside a collection, the Stacking option does not appear when you right-click (Control-click on a Mac) the images.

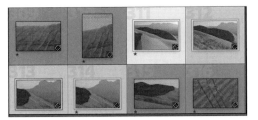

Figure 4.5 Select the photos you want to stack.

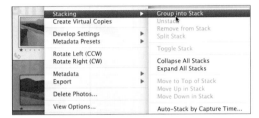

Figure 4.6 Right-click (Control-click on a Mac) the selected images and choose Stacking > Group into Stack.

Figure 4.7 The photos are stacked as one photo with a number indicating how many photos the stack contains.

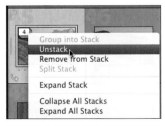

Figure 4.8 To unstack a group, right-click (Control-click on a Mac) the number atop the stack and choose Unstack.

Figure 4.9 To expand a stack, click the bar on either side of the top photo.

Figure 4.10 To collapse a stack, click the bar on the left side of the first photo.

Figure 4.11 In the Grid view, click on the photo you want to add to the stack.

Figure 4.12 Drag and drop the photo on the stack and a thick, black border appears.

To expand/collapse a stack:

1. In the Grid view, a stack is marked not only by a small number in the upper-left corner but also by vertical bars down each side of the top photo (**Figure 4.9**). Press the S on your keyboard or click the bar on either side of the photo. The stack expands, with each photo in the stack showing a slightly darker background than other photos in the grid.

2. After you're done looking at the individual photos, press the S on your keyboard or click the vertical bar to the left of the stack's first image or to the right of the stack's last photo to collapse the stack (**Figure 4.10**). The stack collapses down to a single photo.

To add a photo to a stack:

◆ In the Grid view, click on the photo you want to add to the stack (**Figure 4.11**). Drag and drop it on the stack and a thick, black border appears (**Figure 4.12**). Release the cursor and the photo is added to the stack, reflected by the updated small number in the stack's upper-left corner (**Figure 4.13**).

Figure 4.13 Release the cursor and the photo is added to the stack, updating the small number in the stack's upper-left corner.

To remove a photo from a stack:

◆ In the Grid view, expand the stack and find the photo you no longer want included in the stack. Right-click (Control-click on a Mac) the small number in the photo's upper left and in the pop-up menu, choose Remove from Stack (**Figure 4.14**). The photo is no longer included in the stack of related images.

✔ Tip

■ Don't confuse Remove from Stack with Unstack. The first plucks a single photo from the stack, the latter dismantles the entire stack.

To change a stack's top photo:

◆ By default, a collapsed stack displays the first photo in the sequence. To use another photo in the stack, expand the stack, right-click (Control-click on a Mac) the small number in the photo's upper left, and in the pop-up menu, choose Move to Top of Stack (**Figure 4.15**). That photo becomes the stack's cover photo.

Figure 4.14 Right-click (Control-click on a Mac) the upper-left number of the photo and choose Remove from Stack.

Figure 4.15 Right-click (Control-click on a Mac) the upper-left number of the photo and choose Move to Top of Stack.

Figure 4.16 Select the photos you want to auto stack. If you want, you can select entire folders using the Folders panel.

Figure 4.17 Choose Photo > Stacking > Auto-Stack by Capture Time.

Figure 4.18 Set the Time Between Stacks slider anywhere between 0 seconds and 1 hour. Adjust the time based on the stack count in the lower left and click Stack.

To auto-stack photos by capture time:

1. Select the photos you want to stack. It can be an entire folder, a single photo session, or the results of a photo search (**Figure 4.16**).

2. From the Menu bar, choose Photo > Stacking > Auto-Stack by Capture Time (**Figure 4.17**).

3. Set the Time Between Stacks slider anywhere between 0 seconds (the far right) and 1 hour (the far left) (**Figure 4.18**). The number of stacks (and unstacked photos) based on the setting appears in the lower left of the dialog box. Adjust if necessary, and click Stack.

4. In the Grid view, all the photos remain expanded (unstacked), but their borders have changed to indicate whether they belong to a stack (**Figure 4.19**). Light-bordered photos are *not* part of any stack; dark-bordered ones are part of a stack. The beginning of each stack shows a small number for how many photos belong to that stack. Roll the cursor over any dark-bordered photo and you'll see a number for its position in the stack sequence (**Figure 4.20**).

(continues on next page)

Figure 4.19 The photos remain unstacked, but those with dark borders now belong to a stack.

Figure 4.20 Roll the cursor over any dark-bordered photo to see its position number within the stack.

ADJUSTING YOUR REVIEW SETUP

5. To collapse a particular stack, double-click the small number of the first photo in the stack (**Figure 4.21**). The stack collapses (**Figure 4.22**). To re-expand it, double-click the first photo again.

or

To collapse all the stacks, right-click (Control-click on a Mac) the small number in the upper left of any photo and choose Collapse All Stacks in the pop-up menu (**Figure 4.23**). All the selected photos collapse into their respective stacks (**Figure 4.24**). To re-expand all the stacks, right-click (Control-click on a Mac) the upper left of any stacked photo and choose Expand All Stacks in the pop-up menu.

✔ Tips

- How long an interval you choose when defining your stacks depends on the subject. For a sports event, you might pick an interval of no more than a few seconds. For landscapes, it might be an hour, the maximum amount.

- Step 5's Collapse All Stacks command offers a quick way to clean up your Grid view, and then you can expand a single stack for review.

- All the stacking commands also can be found by choosing Photo > Stacking and making a choice in the drop-down menu.

Figure 4.21 To collapse a particular stack, double-click the small number of the first photo in the stack.

Figure 4.22 To re-expand a stack, double-click the first photo again.

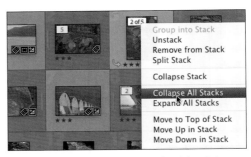

Figure 4.23 To collapse all the stacks, right-click (Control-click on a Mac) the number in the upper left of any photo and choose Collapse All Stacks.

Figure 4.24 With all stacks collapsed, the numbers tell how many photos each stack contains.

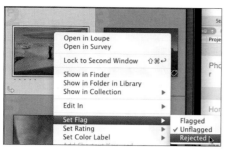

Figure 4.25 To mark rejects, right-click (Control-click on a Mac) a photo and choose Set Flag > Rejected.

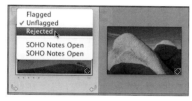

Figure 4.26 In the Grid view, you can click the upper-left corner of a selected image and choose Rejected.

Figure 4.27 In the Compare view, click the black flag at the bottom left of the photo you want to mark as rejected.

Figure 4.28 If the flagging option for the Library module toolbar is active, you can click the black flag in the toolbar.

Flagging Photos

Flagging your photos as soon as you import them lets you quickly mark poor-quality photos as rejects (a black flag) and nicer ones as picks (a white flag). You need to be the toughest judge of your work at this point. Otherwise, you'll eventually clog up your hard drive with bad and so-so photos. Whether you start by marking your rejects or your picks is up to you. I find the process goes faster marking the rejects first. I also hold off actually deleting photos until after a complete review.

To mark rejects:

1. In the Filmstrip or any of the four view modes (Grid, Loupe, Survey, or Compare), select one or more photos you want to mark as rejected. Then, depending on your view and toolbar settings, do one of the following:

 ▲ Right-click (Control-click on a Mac) a photo and in the pop-up menu, choose Set Flag > Rejected (**Figure 4.25**).

 ▲ Press the X on your keyboard.

 ▲ If you're in the Grid view, click the upper-left corner of one of the selected images and choose Rejected in the pop-up menu (**Figure 4.26**).

 ▲ If you're in the Compare view, click the black flag at the bottom left of the photo you want to mark as rejected (**Figure 4.27**).

 ▲ If the flagging option for the Library module toolbar is active, click the black flag in the toolbar (**Figure 4.28**).

(continues on next page)

2. The rejected photo(s) are marked with a black flag and, in the Filmstrip and Grid view, dimmed compared to unrejected photos (**Figure 4.29**).

✔ Tip

■ If you're looking for the quickest way to mark rejects, use the Painter tool or the keyboard's X key in tandem with the forward arrow key. (For more information on using the Painter tool, see 66.)

Figure 4.29 A rejected photo is marked with a black flag and appears dimmed.

Figure 4.30 In the Compare view, click the white flag at the bottom left of the photo you want to mark as picked.

Figure 4.31 White flags mark your picks; black flags mark your rejects, which also are dimmed.

To mark picks:

1. In the Filmstrip or any of the four view modes (Grid, Loupe, Survey, or Compare), select one or more photos you want to mark as flagged. Then, depending on your view and toolbar settings, do one of the following:

- ▲ Right-click (Control-click on a Mac) and in the pop-up menu, choose Set Flag > Flagged.

- ▲ Press the P on your keyboard.

- ▲ If you're in the Grid view, click the upper-left corner of one of the selected images and select Flagged in the pop-up menu.

- ▲ If you're in the Compare view, click the white flag at the bottom left of the photo (**Figure 4.30**).

- ▲ If the flagging option for the Library module toolbar is active, click the white flag in the toolbar.

2. The white flag appears by the picked photo(s) (**Figure 4.31**).

✔ Tips

- ■ The quickest way to mark picks is to use the Painter tool, or alternate between pressing the keyboard's P key and forward arrow key. (For more information on using the Painter tool, see the next page.)

- ■ Any time after marking your picks, you can quickly gather them up by choosing from the Menu bar, Edit > Select Flagged Photos. It's then easy to create a Quick Collection or custom collection. (For more information, see "Creating and Using Collections" on page 107.)

To mark photos using the Painter tool:

1. Turn on the toolbar (View > Show Toolbar or press the T on your keyboard).

2. Click the triangle at the far right of the toolbar and choose Painter in the pop-up menu (**Figure 4.32**).

3. Click the Painter tool (the spray can) in the toolbar (**Figure 4.33**).

4. Click the Paint pop-up menu that appears and choose Flag (**Figure 4.34**). Click the *second* Paint pop-up menu that now appears and make a choice based on whether you want to mark photos as Flagged, Unflagged, or Rejected (**Figure 4.35**).

Figure 4.32 To mark photos using the Painter tool, click the triangle at the far right of the toolbar and choose Painter.

Figure 4.33 Click the spray can in the toolbar to activate the Painter tool.

Figure 4.34 Click the Paint pop-up menu that appears and choose Flag.

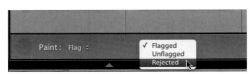

Figure 4.35 Use the *second* Paint pop-up menu to choose whether you want to mark photos as Flagged, Unflagged, or Rejected.

Figure 4.36 Position the spray can over a photo and click once (left). The photo is dimmed and the cursor changes into an eraser (right).

Figure 4.37 A flag appears in the photo's upper left, along with a note confirming your action.

Figure 4.38 To mark several photos, click and drag the cursor over them. A note confirms the action.

Figure 4.39 To unmark a photo, move the cursor over the photo. When it becomes an eraser, click once.

5. In the main window, find a photo you want to mark, position your cursor (now a little spray can) over it (left, **Figure 4.36**). Click once and the photo is dimmed and the cursor changes from a spray can to an eraser (right, **Figure 4.36**).

A flag appears in the photo's upper left, along with a note confirming your action. (What appears is based on your step 4 choice; in the example, a black flag and the related Set as Rejected note appear (**Figure 4.37**).)

6. To mark another photo, repeat steps 4 and 5. Or to quickly mark multiple photos, click once and drag the cursor over those photos (**Figure 4.38**).

✔ Tip

- To unmark a photo, make sure the Painter tool is selected in the toolbar. Move the cursor over the photo and it becomes an eraser (**Figure 4.39**). Click once to unmark a single photo or click and hold, and then drag to unmark multiple photos. A Remove Flag note confirms your action (**Figure 4.40**).

Figure 4.40 A note confirms your action, and the photo is no longer dimmed.

FLAGGING PHOTOS

Using Ratings and Labels

There is no right or wrong way to use Lightroom's ratings and color labels. Some photographers use ratings a lot, others hardly at all. Some love the color labels, others can't stand them. When reviewing photos, I'm quite conservative in awarding four or five stars to photos. That leaves me some leeway later for marking truly standout photos. It's much easier to upgrade a few three-star photos to five stars than to go back and revise downward all your over-rated photos. I use the color labels to designate temporary categories for photos, such as applying purple to images that still need a lot of development work. As I tweak photos, I shift the color labels upward until I finally apply red to photos ready to post on the Web or print. That's one approach. Other photographers use collections (explained in the next chapter) to track their workflow. It may take some experimenting to discover how you best like to work.

To turn on ratings or labels in the Grid view, see "Grid and Loupe View Options" on page 39. To use ratings or labels to find particular photos, see "Using the Library Filter" on page 96.

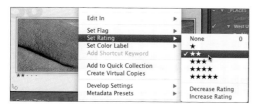

Figure 4.41 To apply ratings, you can right-click (Control-click on a Mac) a photo, then choose Set Rating and the number of stars you want applied.

Figure 4.42 If the toolbar's ratings option is active, select the photo(s) and click the appropriate star.

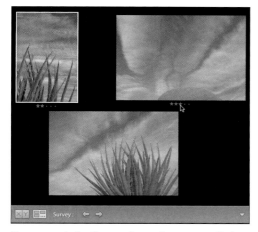

Figure 4.43 In the Survey view, ratings are applied only to the photo you click on directly.

To apply ratings:

1. In the Filmstrip or any of the four view modes (Grid, Loupe, Survey, or Compare), select one or more photos to which you want to apply the same rating. Then, depending on your view and toolbar settings, do one of the following:

 ▲ Press the 1 through 5 keys.

 ▲ Right-click (Control-click on a Mac) and in the pop-up menu, choose Set Rating and the number of stars you want applied (**Figure 4.41**).

 ▲ If the ratings option in the Library module's toolbar is active, click the appropriate star in the toolbar (**Figure 4.42**).

 ▲ If you're in the Grid or Compare view, click one of the five dots below any selected image. (The first dot corresponds to one star, the second to two stars, and so on.)

 ▲ Select the spray can button in the toolbar, set the rating and apply to one or more photos. (For more information on using the Painter tool, see "To mark photos using the Painter tool" on page 66.)

2. The corresponding star rating is applied.

✔ Tips

■ In any view mode, to remove ratings from the selected photos, press the 0 (zero) key. Or press any star twice to toggle off all the stars.

■ If you're in the Survey view, the rating is not applied to all the selected photos. Instead, it's applied only to the photo you click on directly. This allows you to apply different ratings within the selected photos (**Figure 4.43**).

To apply color labels:

1. In the Filmstrip or any of the four view modes (Grid, Loupe, Survey, or Compare), select one or more photos to which you want to apply the same label. Then, depending on your view and toolbar settings, do one of the following:

 ▲ Press the 6 through 9 keys, which correspond with the red through blue labels. (Oddly, there is no key for the fifth label, purple.)

 ▲ Right-click (Control-click on a Mac) and choose Set Color Label and the label you want applied in the pop-up menu (**Figure 4.44**).

 ▲ If you're in the Grid or Compare view, click the gray square at the bottom-right corner of one of the selected images and select a label in the pop-up menu (**Figure 4.45**).

 ▲ If the label option for the toolbar is active, click the appropriate label in the toolbar (**Figure 4.46**).

 ▲ Select the spray can button in the toolbar, set the color label and apply to one or more photos. (For more information on using the Painter tool, see "To mark photos using the Painter tool " on page 66.)

2. The color label is applied.

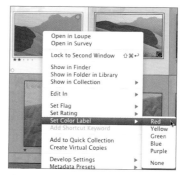

Figure 4.44 To apply color labels, right-click (Control-click on a Mac) a photo and choose Set Color Label and the label you want used.

Figure 4.45 In the Grid or Compare view, click the small gray square at the bottom right of the selected image and select a label.

Figure 4.46 If the toolbar's label option is active, select the photo(s) and click the appropriate color.

Figure 4.47 Choose Metadata > Color Label Set > Review Status to switch to Lightroom's second built-in label set.

Figure 4.48 After switching, a new set of label choices appears when you right-click (Control-click on a Mac) a photo and choose Set Color Label.

To use the Review Status label set:

◆ Besides the Default label set, Lightroom includes a second label set that you can use to mark a photo's review status. To switch, choose Metadata > Color Label Set > Review Status (**Figure 4.47**). This label set now is available whenever you right-click (Control-click on a Mac) a photo and choose Set Color Label (**Figure 4.48**). To switch back to the default set, which just uses the names of colors, choose Metadata > Color Label Set > Default.

To create a new label set:

1. While in the Library module, from the Menu bar choose Metadata > Color Label Set > Edit (**Figure 4.49**).

2. In the Editor Color Label Set dialog box, choose Default in the Preset drop-down menu (top, **Figure 4.50**).

3. Type in the new text you want to use instead of the existing label text. Repeat for each label you want to change (bottom, **Figure 4.50**).

4. Do *not* click the Change button. Instead, click the Preset drop-down menu at the top and choose Save Current Settings as New Preset (**Figure 4.51**).

Figure 4.49 To create a new label set, choose Metadata > Color Label Set > Edit.

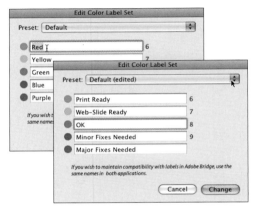

Figure 4.50 Choose Default in the Preset drop-down menu and type new text for each label.

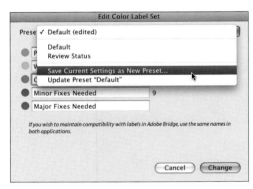

Figure 4.51 Click the Preset drop-down menu and choose Save Current Settings as New Preset.

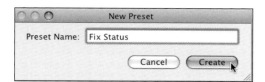

Figure 4.52 Name your new set and click Create.

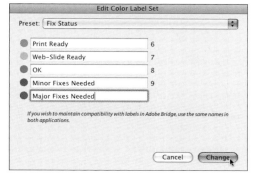

Figure 4.53 Choose your new set in the Preset drop-down menu and click Change.

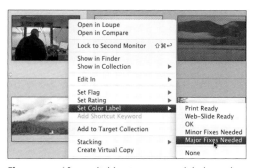

Figure 4.54 After switching to your new label set, the new labels are just a right-click (Control-click on a Mac) away.

Figure 4.55 By returning to the Edit Color Label Set dialog box, you can delete or rename any label set.

5. In the New Preset dialog box, name your new set and click Create (**Figure 4.52**).

6. When the Edit Color Label Set reappears, choose your new set in the Preset drop-down menu and click Change (**Figure 4.53**). The new preset is saved.

7. To switch to your new preset, choose Metadata > Color Label Set and choose it in the drop-down menu. Now, you can right-click (Control-click on a Mac) a photo and apply the labels from your new preset (**Figure 4.54**). To switch to the another preset, choose Metadata > Color Label Set and make another choice.

✔ Tips

■ If you ever want to delete or rename a label set, choose Metadata > Color Label Set > Edit. In the Edit Color Label Set dialog box, select the set name in the Preset drop-down menu (if it's not already selected) and release the cursor. Click the Preset drop-down menu again and you'll have the choice of deleting or renaming the selected label set (**Figure 4.55**). To apply the change, click the Change button to close the dialog box.

■ While Lightroom calls these label sets "presets," don't confuse them with the "presets" you'll find in the Develop module, which apply custom development adjustments to your photos.

Using the Compare and Survey Views

Despite all their viewing options, sometimes the Filmstrip and Grid views are not the best ways to review your photos. That's when the Compare or Survey views may prove just the ticket. The Compare view lets you examine two photos side by side. The Survey view lets you look over a larger number of photos, limited only by how many you want to crowd into the main window.

Figure 4.56 In the Filmstrip or Grid view, select two photos you want to closely compare, and click the toolbar's Compare view button.

To use the Compare view:

1. In the Filmstrip or Grid view, select two photos you want to closely compare (**Figure 4.56**).

2. Press the C on your keyboard or click the Compare view (X|Y) button in the toolbar. The two photos appear side by side in the main Lightroom window with the left photo labeled Select and the right photo labeled Candidate (**Figure 4.57**). (The Select photo is your current best shot, and the Candidate photo is one you're judging against it.) A thin white line marks the Select photo as active; to make the Candidate photo active instead, click it.

Figure 4.57 The two photos appear side by side in the main Lightroom window with the left photo labeled Select and the right photo labeled Candidate. A thin white line marks the Select photo as the active photo.

Figure 4.58 With the toolbar's Link Focus button *unlocked*, you can adjust the Zoom slider independently for each photo.

Figure 4.59 With the toolbar's Link Focus button *locked*, any adjustments with the Zoom slider apply to both photos.

Figure 4.60 If when zooming in on one photo you realize you want to enlarge the other photo by the same amount, click the Sync button.

3. To adjust your view of the photos, do one of the following:

▲ Click the toolbar's 🔒 button to switch it to the *unlocked* position. Click to select the first photo you want to adjust, and use the Zoom slider to adjust your view (**Figure 4.58**). If necessary, click the other photo and use the Zoom slider to adjust that view as well.

▲ If you want to zoom in on both photos by the same amount, click the toolbar's 🔒 button to switch it to the *locked* position. Use the Zoom slider to adjust the amount (**Figure 4.59**).

▲ If you start with the toolbar's 🔒 button unlocked, but when zooming in on one photo realize you want to zoom in by the same amount in the other photo, click the Sync button (**Figure 4.60**). The view of the other photo zooms to the same magnification as the active photo (**Figure 4.61**).

(continues on next page)

Figure 4.61 The view of the other photo now zooms to the same magnification as the active photo.

USING THE COMPARE AND SURVEY VIEWS

4. With the view now set, you can make judgments more easily about which photos should be Selects and Candidates. Use the Compare view's tools to switch or compare them (**Figure 4.62**).

5. As you review photos, you also can apply the flags, ratings, and labels to further distinguish photos from each other. In the example, the right (Candidate) photo is sharper, so it's flagged as a pick and then made the Select photo using the Compare view toolbar (**Figure 4.63**).

6. Once you finish comparing photos, click the toolbar's Done button. The Compare view switches to the Loupe view.

✔ Tips

■ When moving around in a zoomed view, opening the Navigator panel helps you see where you are in the active photo (**Figure 4.58**).

■ It can be helpful to turn on the photo info options when comparing photos (Ctrl-I/Cmd-I) (**Figure 4.58**). (For more information, see Grid and Loupe View Options on page 39.)

■ The Compare view also is useful when working with virtual copies to which different develop settings have been applied. (For more information, see page 130.)

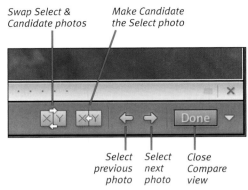

Swap Select & Candidate photos

Make Candidate the Select photo

Select previous photo

Select next photo

Close Compare view

Figure 4.62 Use the Compare view's toolbar buttons when reviewing Select and Candidate photos.

Figure 4.63 The right (Candidate) photo is sharper, so it's flagged as a pick and then made the Select photo using the Compare view toolbar.

Using Compare view with the Filmstrip

When comparing similar photos not shot in a continuous sequence, the Compare view is easier to use with the Filmstrip visible (**Figure 4.64**). You can, for example, choose a Select and Candidate photo in the Filmstrip and mark either as Flagged or Rejected. Rejected photos appear dimmed in the Filmstrip. Press your keyboard's forward and back arrows to quickly compare the Select photo against another Candidate photo (**Figure 4.65**).

Figure 4.64 When comparing similar photos not shot in a continuous sequence, the Compare view is easier to use with the Filmstrip.

Figure 4.65 The Filmstrip makes it easy to quickly compare the Select photo against another Candidate photo (right).

USING THE COMPARE AND SURVEY VIEWS

To use the Survey view:

1. In the Filmstrip or Grid view, select several photos you want to review.

2. Press the N on your keyboard or click the Survey view button in the toolbar (**Figure 4.66**). All the selected photos appear in the main Lightroom window.

3. Click to select any photo in the main window, and a large X appears in the bottom right (**Figure 4.67**).

4. To remove a photo from the Survey view, click the X. The photo is removed only from the Survey view, but remains part of your catalog and is not deleted.

5. As you work in Survey view, you also can right-click (Control-click on a Mac) any photo and use the pop-up menu to apply flags, ratings, or labels.

6. Continue removing photos by clicking the lower-right X until you get down to your final two choices. Click your favorite, and click the small white flag in the lower left to mark it as your top pick (**Figure 4.68**). You can create a new Survey view collection by selecting other photos in the Filmstrip, or switch to another view.

✔ Tip

■ The Survey and Compare views really come into their own when you have a second monitor to use. (For more information, see "Opening a Secondary Library View" on page 44.)

Figure 4.66 In the Filmstrip, select several photos you want to review and click the toolbar's Survey view button.

Figure 4.67 All the selected photos are grouped in the main window. Click any photo and a large X appears in the bottom right.

Figure 4.68 When you get down to your final two choices, click the small white flag in the lower left of the favorite to mark it as your top pick.

Figure 4.69 Select the photo you want to remove or delete. In this case, the left photo is flagged as a reject.

Figure 4.70 If you only want to remove the photo from the Lightroom catalog, choose Remove.

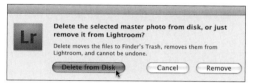

Figure 4.71 If you want to remove the photo from the Lightroom catalog *and* delete it from your hard drive, choose Delete from Disk.

Removing or Deleting Photos

Lightroom gives you two choices when you're ready to weed out those photos you've marked as bad or second-rate. You can *remove* a photo from the current Lightroom catalog or *delete* it from your hard drive. Removing photos does not erase the image but simply tells Lightroom to ignore it. In effect, the pointer from the catalog back to the actual image is severed, which does not free up much space on your hard drive. In contrast, deleting a photo moves it to your Recycle Bin/Trash. Once you empty the Recycle Bin/Trash, the photo will be erased and you regain that 5–10Mb of space on the hard drive. Whether you remove or delete depends on your ruthlessness as an editor— and whether you truly want a photo gone for good. By the way, removing or deleting those photos *before* you start major keywording saves you a lot of work. (Keywording is covered in the next chapter.)

To remove or delete photos:

1. Select the photo(s) you want to remove or delete (**Figure 4.69**).

2. Press the Backspace/Delete key.

3. In the dialog box that appears, do one of the following:

 ▲ If you only want to remove the photo(s) from the Lightroom catalog, choose Remove (**Figure 4.70**).

 or

 ▲ If you want to remove the photo(s) from the Lightroom catalog *and* delete it from your hard drive, choose Delete from Disk (**Figure 4.71**).

(continues on next page)

REMOVING OR DELETING PHOTOS

4. With either choice, the photo no longer appears in the Filmstrip or the main Lightroom window (**Figure 4.72**). If you chose to delete the photo, it's moved to the Recycle Bin/Trash, along with the catalog's accompanying XMP (metadata) file (**Figure 4.73**).

✔ Tips

■ You can *remove* a photo from the catalog without bothering with the Delete from Disk/Remove dialog box (**Figure 4.70**). In step 2, press Alt-Backspace/Option-Delete, and the photo is removed immediately.

■ Use Ctrl-Z/Cmd-Z to undo your action if you *remove* a photo by accident.

■ There is no undo command if you accidentally *delete* a photo. However, until you empty your Recycle Bin/Trash, you can open it and move the photo back to your desktop. Then you can reimport the photo into Lightroom.

■ You also can use the Library Filter to quickly find all photos marked as rejects or assigned low ratings. (For more information, see "Using the Library Filter" on page 96.)

Figure 4.72 In either case, the photo no longer appears in Lightroom's main window or Filmstrip.

Figure 4.73 If you choose to *delete* the photo, it's moved to the Recycle Bin/Trash, along with the catalog's accompanying XMP file.

REMOVING OR DELETING PHOTOS

5

USING KEYWORDS

Keywords act as tags for your photos. Because they are tucked into the metadata of each photo, they stay out of the way until you need them to help you find a particular photo. When you first start adding images to Lightroom, the keyword feature may seem more bother than it's worth. Once your catalog grows to several hundred (or thousand) images, however, keywords become essential for pulling that one photo from the digital haystack. If you hope to sell any of your images, remember: Stock image agencies depend on keywords when seeking photos. So keywords may be a bit of a bother, but it can be worth the time—and the money.

Your first chance to apply keywords comes when you import photos into Lightroom, as explained in step 11 on page 22. The rest of the time you'll use the keyword tools found in the Library module's Keywording and Keyword List panels.

Creating Keywords

Lightroom gives you two ways to create keywords. The first, using the Keywording panel, is quick and simple. The second, using the Keyword List panel, is a tad more involved but offers options to create nested keywords and keyword synonyms. An example of nested, also called grouped, keywords might be: Places > West US > Southwest > Utah > Capitol Reef N.P. Add the keywords Capitol Reef N.P. to any photo and it's automatically also tagged with the Utah, Southwest, West US, and Places tags (**Figure 5.1**). This is probably the single most effective way to manage what otherwise can become a sprawling list of keywords. The Keyword List panel's synonyms feature helps you anticipate other words that might be used in searching your photos later on. By entering "amphibian" as a synonym for frog. for example, you reduce the risk of not finding a relevant photo simply because you used another word in the search. (For more information on searching for photos, see "Using the Library Filter," on page 96.)

As you create keywords over time, Lightroom can track those words and offer suggestions of similarly spelled keywords. This auto-completion feature not only saves you time but also helps keep your keyword spellings consistent. (For more information, see page 86.) Lightroom also makes it easy to apply existing keywords by simply dragging and dropping them onto photos.

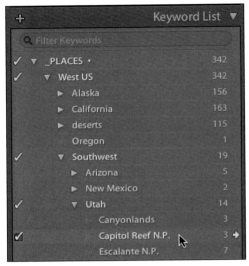

Figure 5.1 With nested keywords, adding a "child" keyword to a photo automatically applies its "parent" terms as well.

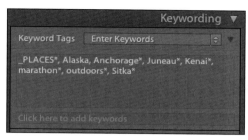

Figure 5.2 In the Right Panel Group, the Keywording panel offers a simple way to add keywords.

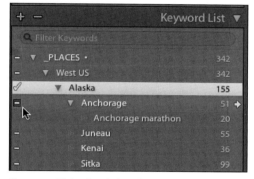

Figure 5.3 Sitting just below the Keywording panel, the Keyword List panel includes options to create nested (parent-child) keywords.

To see a photo's existing keywords:

◆ In the Library module, select the photo(s) you want to check for keywords and:
 ▲ Expand the Keywording panel and look in the Keyword Tags text box. If you've selected multiple photos, keywords applied to only some of the photos have an asterisk (**Figure 5.2**).

 or

 ▲ Expand the Keyword List panel. Keywords applied to every selected photo are checked; keywords applied to only some of the selected photos have a dash (**Figure 5.3**).

✔ Tip

■ In the Keyword List panel, if you click the arrow at the far right of any line, the Library Filter feature displays only the photo(s) to which that keyword is applied. (For more information on the Library Filter, see 96.)

Start General, then Get Specific

Keywording moves along faster if you start by adding keywords that apply to the most photos. For example, add keywords to all your photos from Alaska first, then keyword only the shots from the town of Sitka, and finally those from the Sitka National Historical Park. This broad-to-narrow application of keywords is more efficient—and jogs your memory in creating related keywords.

To create simple keywords:

1. In the Library module, select the photo(s) to which you want to add the same keyword.

2. Expand the Keywording panel and click in the "Click here to add keywords" text box (**Figure 5.4**).

3. Type in the first keyword you want to add, then enter a comma and space, and type the next keyword (**Figure 5.5**).

4. When you're done entering keywords, press Enter/Return. The new keywords are added to the list of keywords applied to the selected photo(s) (**Figure 5.6**).

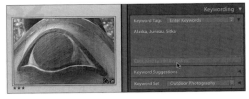

Figure 5.4 To add simple keywords, expand the Keywording panel and click in the "Click here to add keywords" text box.

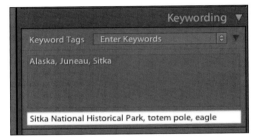

Figure 5.5 Separate the keywords you enter with commas.

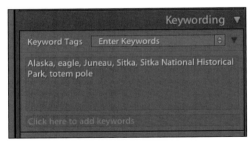

Figure 5.6 When you're done entering keywords, press Enter/Return. The new keywords are added to the selected photos.

Figure 5.7 To add nested keywords and synonyms, click the + button in the upper left of the Keyword List panel.

Figure 5.8 Enter keywords in the Keyword Tag text box, separated by commas. Use the Synonyms text box to add search terms that might be used instead of the keywords. Then choose the appropriate Keyword Tag Options.

Figure 5.9 The new keyword is added to the Keyword List panel.

To create nested keywords and synonyms:

1. In the Library module, select the photo(s) to which you want to add the same keyword.

2. Click the + button in the upper left corner of the Keyword List panel (**Figure 5.7**). The Create Keyword Tag dialog box appears.

3. In the Keyword Tag text box, type in the keyword you want to add (**Figure 5.8**). Type in any synonyms that you expect you or others might use later to search for photos like this one. Enter a comma and space after each synonym.

4. Choose which of the Keyword Tag Options you want applied (For more information, see the "Keyword Tag Options" sidebar.).

5. Click Create and the keyword appears in your Keyword List (**Figure 5.9**).

✔ Tip

■ You also can download commercial sets of nested keywords from the Web. Just search for the term "controlled vocabulary."

CREATING KEYWORDS

To set the catalog to suggest existing keywords:

1. From the Menu bar, choose Edit > Catalog Settings (Windows) or Lightroom > Catalog Settings (Mac). The Catalog Settings dialog box appears.

2. Click the Metadata tab and select Offer suggestions from recently entered values (**Figure 5.10**). Make sure the other two boxes, which control how metadata is saved, also are selected. Click OK to close the dialog box.

 Now when you begin to type a keyword, Lightroom suggests similarly spelled keywords, which helps you remember keywords you've already created (**Figure 5.11**). To select a suggested keyword, choose it in the drop-down menu and press Enter/Return twice.

Figure 5.10 Click the Metadata tab and select Offer suggestions from recently entered values. With this on, Lightroom auto-completes keywords as you type them.

Figure 5.11 When you begin to type a keyword, Lightroom suggests similarly spelled existing keywords.

Keyword Tag Options

Put inside "___": This option appears only if you select an existing keyword in the Keyword List before clicking the + button. You can use this option to "nest" your new keyword in a more inclusive keyword, such as "_PLACES" in the example (Figure 5.8). (For more information on nested keywords, see "To rearrange keyword groups" on page 94.)

Add to selected photos: Checked by default, which usually makes sense since you selected the photo(s) in step 1. Sometimes, however, you may remember another keyword you'll want to apply later to some other shots. By unchecking the option, you can create keywords without applying them to the current photos.

Include on Export: Checked by default, this option sends the keyword tag along with any photos you later export. Whether you leave it checked may depend on who will be using the exported photos: yourself on another computer or a client that you may—or may not—want to see the keywords.

Export Containing Keywords: This option sends the keywords and any *containing* keywords along with the exported photos (e.g. "West US" as well as "Alaska"). As with the previous option, whether you leave this option checked depends on the needs of the person receiving the exported photos.

Export Synonyms: This option includes your synonyms, along with the keywords, with any exported photos.

Figure 5.12 Select the photo(s) to which you want to add a keyword. Click a keyword in the list of Keyword Suggestions.

Figure 5.13
The keyword is added to the photo's list of keywords in the Keywording panel.

Figure 5.14 Select and drag the photo(s) to your target keyword, and a stack of thumbnails appears above the keyword. Release your cursor and the keyword is added to the photo(s).

Figure 5.15 Drag the keyword onto the selected photo(s). The keyword appears over the photo nearest the cursor, along with a green plus sign. Release your cursor and the keyword is added to the photo(s).

To quickly apply existing keywords:

◆ Select the photo(s) to which you want to add a keyword. Expand the Keyword Suggestions list in the Keywording panel, and click the keyword you want to add (**Figure 5.12**). The keyword is added to the photo(s) list of keywords (**Figure 5.13**).

or

◆ Expand the Keyword List panel so that you can see the keyword you want to add. Select the photo(s) to which you want to add the keyword and drag them onto the keyword. A stack of thumbnails appears over the highlighted keyword (**Figure 5.14**). Release your cursor and the keyword is added to the photo(s).

or

◆ Expand the Keyword List panel so that you can see the keyword you want to add. Select your photo(s). Drag the keyword onto the selected photo(s). The keyword appears over the target photo, along with a green plus sign (**Figure 5.15**). Release your cursor and the keyword is added to the photo(s).

✔ Tip

■ In the third method above, it's much easier to see the keyword above the photos if the Grid view is set to Expanded Cells instead of Compact Cells. (For more information on the Expanded Cells option, see "Grid and Loupe View Options" on page 39.)

APPLYING EXISTING KEYWORDS

Using Keyword Sets

Keyword sets are great for pulling together a set of words that you often apply in the same work session. If you often shoot photos of your family—and who doesn't—you might create a keyword set containing their names. That way, you can access the names with a single click, which can be handy when you're working through a group of family picnic photos. While each keyword set can contain no more than nine words, there's no limit on how many sets you can create.

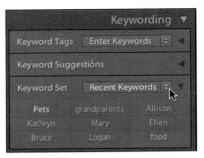

Figure 5.16 Use the Keyword Set drop-down menu to choose Recent Keywords.

Lightroom gives you a head start on creating keyword sets by always tracking your most recently used keywords. When, for example, you finish working with photos with similar locations or subjects, the keywords you assigned can then be quickly turned into a permanent keyword set. Lightroom also includes three keyword sets built around three of the most common photo subjects: Outdoor Photography, Portrait Photography, and Wedding Photography.

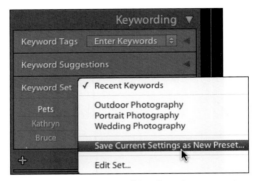

Figure 5.17 Use the Keyword Set drop-down menu to choose Save Current Settings as New Preset.

To convert recent keywords into a set:

1. After a session of creating or adding keywords for photos with similar subjects, expand the Keywording panel. Use the Keyword Set drop-down menu to choose Recent Keywords (**Figure 5.16**). Don't worry if the recent keywords panel contains some unrelated keywords; you can edit them in a moment.

2. Use the Keyword Set drop-down menu to choose Save Current Settings as New Preset (**Figure 5.17**).

3. In the New Preset dialog box, name your new set (called a preset) and click Create (**Figure 5.18**). The new keyword set is selected in the Keyword Set drop-down menu.

Figure 5.18 Name your new keyword set (here called a preset) and click Create.

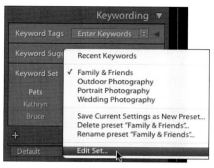

Figure 5.19 Use the Keyword Set drop-down menu to choose "Edit Set."

Figure 5.20 Select any keyword you don't want as part of this keyword set (top). Delete or replace it with a new keyword and click Change (bottom).

Figure 5.21 When the new keyword set reappears, it will not reflect your edits, so use the Keyword Set drop-down menu to choose Update Preset.

4. Use the Keyword Set drop-down menu to choose Edit Set (**Figure 5.19**).

5. In the Edit Keyword Set dialog box, select any keywords you don't want as part of this keyword set. Delete them or replace them by typing in new keywords (**Figure 5.20**). It's OK to add keywords you've never used before. Click Change to apply the edits and close the dialog box.

6. When the new keyword set reappears, it will not reflect your edits, so use the Keyword Set drop-down menu to choose Update Preset... (**Figure 5.21**). The keyword set updates to reflect the changes (**Figure 5.22**). Now this set will be available in the drop-down menu when you are working in this catalog. You also can export the keyword set for use in another catalog.

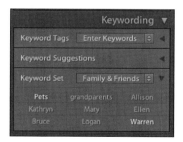

Figure 5.22 The keyword set updates to reflect the changes.

lect and use a keyword set:

1. ...pand the Keywording panel, click the Keyword Set drop-down menu, and choose a keyword set of your own or one Lightroom's three built-in keyword sets: Outdoor Photography, Portrait Photography, or Wedding Photography (**Figure 5.23**).

Figure 5.23 Click the Keyword Set drop-down menu and choose one of Lightroom's three built-in keyword sets.

2. Once that set's keywords appear, you can click any one of the nine words to apply it to a selected photo (**Figure 5.24**).

✔ Tip

■ You can edit and add to Lightroom's built-in keyword sets. See steps 5 and 6 in the previous section "To convert recent keywords into a set."

Figure 5.24 Once a set's keywords appear, you can click any one of the nine words to apply it to a selected photo.

USING KEYWORD SETS

Figure 5.25 To remove a keyword from a photo, select it in the Keywording panel and press Backspace/Delete.

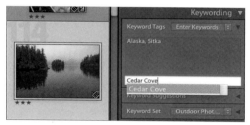

Figure 5.26 If you're in the main Keywording text box, press Tab to jump to the "Click here to add keywords" text box. You can then add other keywords.

Editing Keywords

It's easy at any point to remove, delete, or edit a keyword. Lightroom automatically updates every instance of the keyword. That means your keywords can evolve or grow more specific as your collection of photos grows. It makes it a drag-and-drop affair to reorder your nested keywords, no matter how elaborate the system becomes.

To remove a keyword from a photo:

1. Select the photo(s) from which you want to remove a keyword.

2. In the Keywording panel's list of applied keywords, select the keyword(s) you want to remove along with the comma and asterisk (**Figure 5.25**). (See Tip.)

3. Press Backspace/Delete to remove the keyword(s). Repeat the steps if you need to delete more keywords from the selected photo(s).

✔ Tip

- In step 2, you can select just the keyword with a double-click and then in step 3, if you press Tab after pressing Backspace/ Delete, the keyword's comma and asterisk also are automatically removed. The Tab moves the cursor to the "Click here to add keywords" text box, which makes fast work of adding other keywords (**Figure 5.26**).

EDITING KEYWORDS

To delete a keyword from the catalog:

1. In the Keyword List panel, right-click (Control-click on a Mac) the keyword you want to remove from the Lightroom catalog and choose Delete in the pop-up menu (**Figure 5.27**).

2. When the alert dialog box asks if you're sure about the action, click Delete (**Figure 5.28**). The keyword is deleted from the current Lightroom catalog, as well as from any photos within the catalog. (The photo itself is not deleted.)

✔ Tip

- If you want to remove keywords that you've never applied to any photos in the catalog, in the Menu bar choose Metadata > Purge Unused Keywords. Those words are removed immediately and cannot be retrieved.

To edit keywords:

1. In the Library mode, right-click (Control-click on a Mac) a keyword in the Keyword List panel and choose Edit Keyword Tag in the pop-up menu (**Figure 5.29**).

2. In the Edit Keyword Tag dialog box, type in a new name or add synonyms or change the selected options (**Figure 5.30**). Click Edit to close the dialog box and apply the change.

✔ Tip

- If you only need to change the name, right-click (Control-click on a Mac) the keyword in the Keyword List panel and choose Rename in the pop-up menu.

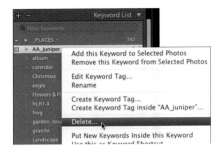

Figure 5.27 To delete a keyword from the entire catalog, right-click (Control-click on a Mac) in the Keyword List panel on the keyword you want to remove and choose Delete.

Figure 5.28 The alert dialog box warns you that the keyword will be deleted from the current Lightroom catalog, as well as from any photos within the catalog. If you're sure about the action, click Delete.

Figure 5.29 To edit a keyword, right-click (Control-click on a Mac) it in the Keyword List panel and choose Edit Keyword Tag.

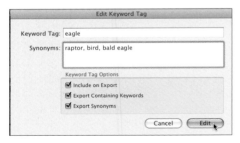

Figure 5.30 In the Edit Keyword Tag dialog box, you can enter a new name, add synonyms, or change the options.

EDITING KEYWORDS

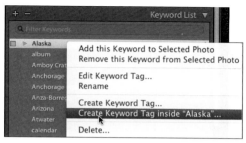

Figure 5.31 In the Keyword List panel, right-click (Control-click on a Mac) what will become the "parent" keyword and choose the Create Keyword Tag inside ... item.

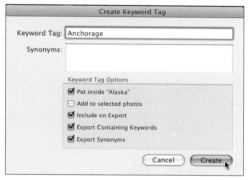

Figure 5.32 Type the new "child" keyword in the Keyword Tag text box and check the Put inside ... option.

Figure 5.33 "Anchorage," the new child keyword, is nested inside "Alaska," now the parent keyword.

To nest a keyword inside another keyword

1. In the Library module, expand the Keyword List panel.

2. Right-click (Control-click on a Mac) a keyword for which you want to create a subgroup and choose the Create Keyword Tag inside ... item in the pop-up menu (**Figure 5.31**). The Create Keyword Tag dialog box appears.

3. Type the new keyword in the Keyword Tag text box and make sure the Put inside ... option is checked (**Figure 5.32**).

4. Click Create to close the dialog box. The new keyword is nested inside the chosen keyword (**Figure 5.33**).

EDITING KEYWORDS

To rearrange keyword groups:

1. In the Library module, expand the Keyword List panel.

2. Click on the keyword you want to rearrange within a keyword group, and drag it to where you want it to appear within the keyword groupings (**Figure 5.34**).

3. Release the cursor and the keyword moves to its new position within the keyword group (**Figure 5.35**).

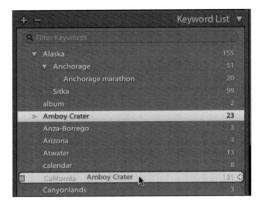

Figure 5.34 In the Keyword List panel, drag the keyword to where you want it to appear within the hierarchy.

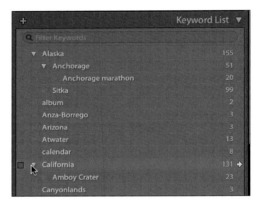

Figure 5.35 The keyword moves to its new position within the keyword group.

FINDING AND COLLECTING IMAGES

6

As the number of images you import into Lightroom inevitably becomes overwhelming, you'll need ways to fetch exactly the photos you need without a lot of work. The Library Filter toolbar provides a powerful way to quickly sift through your images. And in a way, Lightroom's collections work hand in glove with the Library Filter. Anything you find can quickly be turned into a permanent collection that you can use again and again. Together, perhaps, they exemplify the database powers working behind the scenes in Lightroom.

Using the Library Filter

The Library Filter pulls together a variety of ways to search your photos. Using its three main search buttons—Text, Attribute, and Metadata—you can quickly cast a wide net to find all of a particular type of photo or drill down to a single specific image. The Library Filter toolbar also includes a Custom Filter pop-up menu with six predefined searches, plus the ability to tailor your own.

By the way, when the Library Filter is turned on, Lightroom's main window shows only the search results, which can be confusing if you're trying to see all your photos. (See "Searching Without Getting Lost" on page 98.)

As you work with the Library Filter—particularly the ability to create custom filters—you'll see how this feature leads right into the section after this one, "Creating and Using Collections."

To show/hide the Library Filter toolbar:

◆ In the Library module, choose View > Show Filter Bar (**Figure 6.1**).

 or

◆ In the Library module, press the \ (back slash) on your keyboard.

 or

◆ In the *Develop* module, press the - (hyphen) on your keyboard.

 The Library Filter toolbar appears at the top of the main window, ready for use (**Figure 6.2**). Repeat the above action, and the toolbar disappears.

Figure 6.1 To show or hide the Library Filter toolbar, choose View > Show Filter Bar/Hide Filter Bar. Or press the \ on your keyboard to toggle it on or off.

Figure 6.2 The Library Filter's four search buttons—Text, Attribute, Metadata, and Custom Filter—let you find photos several ways. None turns off the filter to show all available photos.

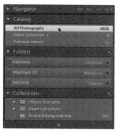

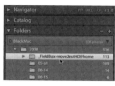

Figure 6.3
Choose All Photographs in the Catalog panel to search every photo in the current catalog, which covers every hard drive listed in the Folders panel.

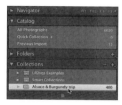

Figure 6.4 To search a specific hard drive or folder, make a choice in the expanded Folders panel.

Figure 6.5 To search a collection, make a choice in the expanded Collections panel.

Figure 6.6 In the Library Filter toolbar, click the Text button to display the Text toolbar below it.

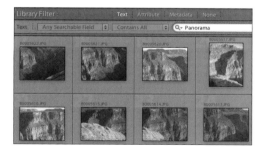

Figure 6.7 Type your search terms in the query field, and the photo results appear in Lightroom's main window.

Figure 6.8 Click the X to clear the previous search so that you can start a new search.

To search for photos by text:

1. Use the Catalog, Folders, or Collections panel to select a photo source for your search (**Figures 6.3, 6.4, 6.5**).

2. In the Library Filter toolbar, click the Text button to reveal the Text toolbar (**Figure 6.6**).

3. By default, the Text toolbar is set for "Any Searchable Field" and "Contains All." That's perfect for a quick broad search, so type your search terms directly into the query field, and the photo results appear in Lightroom's main window (**Figure 6.7**).

4. If you want to start a new text search, click the X to clear the previous search term (**Figure 6.8**)

✔ Tips

- Even if a hard drive is not connected at the moment, you can still search for information about its photos since the Lightroom catalog stores all the information.

- If you need to refine the search, use the Text toolbar's first drop-down menu to specify which fields to search, and the second pop-up menu to narrow or expand what's sought (**Figure 6.9**). Then type your search terms into the query field.

(continues on next page)

Figure 6.9 Use the Text toolbar's first and second pop-up menus to refine your search. Then type your search terms into the query field.

- You do not need to press Enter/Return to trigger the search; the words alone do the trick.

- Press Ctrl-F/Cmd-F to jump straight to the Text entry window from anywhere in the Library module.

- The Library Filter can search through stacked photos, displaying photos in results possibly hidden in a collapsed stack.

- Don't let this throw you off: Search results do not disappear until you enter new search terms. That means that when you initially start a new text search, the main window displays photos from the previous text search. In fact, Lightroom does the same thing for your previous Attribute and Metadata searches as well.

Searching Without Getting Lost

It's possible to hide the Library Filter toolbar but leave the search filters on. That combination makes it hard to tell at a glance if you're seeing all of your photos or only the search results (**Figure 6.10**). To avoid such confusion, keep the toolbar visible whenever you're searching photos. The toolbar eats up some screen real estate, but it's always clear what's going on (**Figures 6.11**, **6.12**).

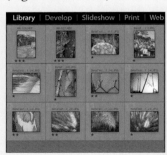

Figure 6.10 Confusion: With the Library Filter toolbar hidden, it's hard to tell if you're seeing all your photos or just the search results.

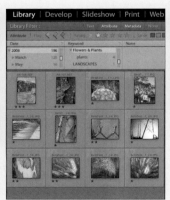

Figure 6.11 No confusion. With the toolbar showing, it's clear these are photos found in a search.

Figure 6.12 With None selected in the toolbar, again it's clear you're seeing all your photos.

Figure 6.13 To search for photos by attribute, click the Attribute button in the Library Filter toolbar.

Figure 6.14 Choose Flag, Rating, or Color (labels), and the results appear in Lightroom's main window.

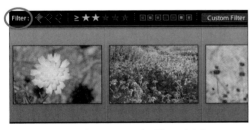

Figure 6.15 You also can use the Filmstrip's buttons to find photos based on their flag, rating, or color label.

To search for photos by attribute:

1. Use the Catalog, Folders, or Collections panel to select a photo source for your search.

2. In the Library Filter toolbar, click the Attribute button to reveal the Attribute toolbar (**Figure 6.13**).

3. Click the Flag, Rating, or Color (labels) applied to the photos you're searching for, and the results appear in Lightroom's main window (**Figure 6.14**).

✔ Tips

- You also can use the Filmstrip's Filter buttons to find photos in the strip based on their flag, rating, or color label (**Figure 6.15**). However, I find the Library Filter toolbar more flexible and less confusing.

- Two Copy Status buttons at the Attribute toolbar's far right enable you to search for virtual or master copies of photos. (For more information on the topic, see 130.)

USING THE LIBRARY FILTER

To search for photos by metadata:

1. Use the Catalog, Folders, or Collections panel to select a photo source for your search.

2. In the Library Filter toolbar, click the Metadata button to reveal the Metadata toolbar (**Figure 6.16**). By default, the Metadata toolbar displays four columns set to Date, Camera, Lens, and Label.

3. To refine your metadata search, click any of the column headers to trigger a pop-up menu offering an amazing 23 choices (**Figure 6.17**). Change the setting in any or all of the columns. You also can add, remove, or resort any column by clicking the small icon in the upper right of any column and making a choice in the pop-up menu.

4. To fine-tune your search even further, you can scroll down the columns listing multiple sub-categories to make more choices. Lightroom's main window displays the ever-narrowing photo results (**Figure 6.18**).

✔ Tip

■ Using the Metadata button, you can combine all three search approaches—Text, Attribute, and Metadata. After clicking the Metadata button, also click the Text and Attribute buttons if you want to order up a super-combo search (**Figure 6.19**).

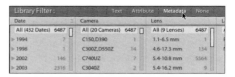

Figure 6.16 To search for photos by metadata, click the Metadata button in the Library Filter toolbar.

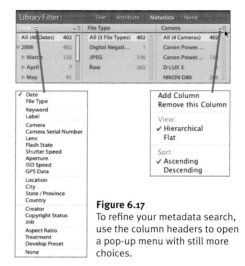

Figure 6.17
To refine your metadata search, use the column headers to open a pop-up menu with still more choices.

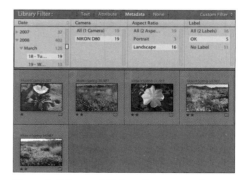

Figure 6.18 As you drill down in your search, Lightroom's main window displays the ever-narrowing photo results.

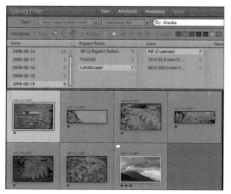

Figure 6.19
You can combine all three search approaches—Text, Attribute, and Metadata—for multi-criteria searches.

USING THE LIBRARY FILTER

Adding and Syncing Metadata

After getting comfortable using the Library Filter to search Lightroom's metadata, you may want to add information for photos directly in the Metadata panel. If you like, you also can then sync all or just some of that metadata to other photos. It saves you from constantly rekeying the same information.

1. Select the photo(s) to which you want to add the same metadata.

2. Use the left-hand pop-up menu, if the Metadata panel is not showing the metadata field(s) you need (**Figure 6.20**).

3. Enter your information in the appropriate metadata fields for the selected photo(s), pressing Enter/Return when you're done with each field. The metadata is added to the selected photos in the Grid (**Figure 6.21**).

4. With these source photo(s) still selected, now also select target photos to which you want to apply some of the metadata entered in step 3. Some of the metadata fields are labeled <mixed> because they do not all contain the same information (**Figure 6.22**).

Figure 6.20 Use the left-hand pop-up menu, if the Metadata panel is not showing the metadata field(s) you need.

(continues on next page)

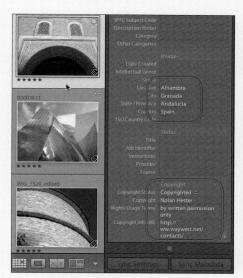

Figure 6.21 Location and copyright metadata is added for the photo selected in the Grid.

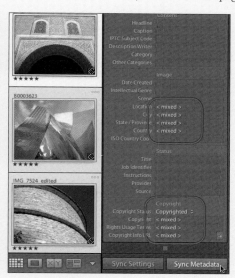

Figure 6.22 Select additional photos to which you want to apply some of the top photo's metadata. Fields labeled <mixed> do not all contain the same location and copyright information.

To switch between search results and all photos:

◆ Click None in the Library Filter toolbar to turn off the search and see all your photos.

or

◆ Press Ctrl-L/Cmd-L to turn the Library Filter off and see all your photos. When the switch takes place, a "Library Filters Off" note also briefly appears in the main window.

<div style="writing-mode: vertical-lr;">USING THE LIBRARY FILTER</div>

Adding & Syncing Metadata *(continued)*

5. Click Sync Metadata and the Synchronize Metadata dialog box lets you check which fields you want to apply to all the photos (**Figure 6.23**). Fields with metadata you do not want applied to all the photos should remain unchecked. Click Synchronize. A task bar tracks the synchronization, which may take a moment, depending on how many photos you selected.

6. Select any of the photos you targeted for syncing in step 4. Only the fields you checked in step 5 are updated with metadata from the source photo(s) (**Figure 6.24**).

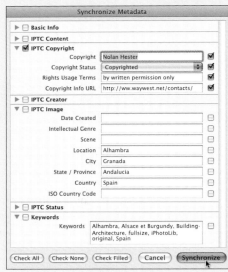

Figure 6.23 Check the fields you want to apply to all the photos (e.g., copyright-related). Leave unchecked fields that you do not want to synchronize (location- and keywords-related).

Figure 6.24 After syncing, the targeted photo (bottom) includes the source photo's copyright but not its location metadata.

Figure 6.25 Click the Custom Filter pop-up menu to choose among six pre-defined schemes.

To use the custom filters:

1. In the Library Filter toolbar, click the Custom Filter pop-up menu (**Figure 6.25**). Choose one of the following:

 ▲ **Default Columns:** Switches the Library Filter to the Metadata toolbar with the columns set to the metadata fields Date, Camera, Lens, and Label.

 ▲ **Filters Off:** Switches to immediately show you *all* the photos in the selected catalog, folder, or collection. It works just like the Library Filter's None button.

 ▲ **Flagged:** Switches the Library Filter to the Attribute toolbar and shows you only photos flagged as Picks.

 ▲ **Location Columns:** Switches the Library Filter to the Metadata toolbar with the columns set to the metadata fields Country, State/Province, City, and Location.

 ▲ **Rated:** Switches the Library Filter to the Attribute toolbar and shows you only photos with a rating of at least one star.

 ▲ **Unrated:** The opposite of the previous option, this one shows you photos without any rating.

 ▲ **Save Current Settings as New Preset:** As explained on the next page, this choice lets you save a particular search setting as a custom filter.

2. After making a choice in the pop-up menu, you can fine-tune the filter settings further to find the exact photos you need. If desired, you can save those settings as a custom filter (see next page).

To save custom filter settings as presets:

1. After creating a particular set of filters with the Text, Attribute, or Metadata choice, you can save the settings for use later. With your settings visible in the Library Filter, click the Custom Filter button (**Figure 6.26**).

2. In the pop-up menu, choose "Save Current Settings as New Preset" (**Figure 6.27**).

3. Type in a name for your custom filter, which Lightroom calls a Preset, and click Create (**Figure 6.28**).

The Preset is added to the Custom Filter list and can be activated at any time by selecting it in the Custom Filter pop-up menu (**Figure 6.29**).

✔ Tip

■ By default, the Custom Filter lists all the filters alphabetically, mixing your filters in with the default filters. You can group your filters by adding letters or dashes at the beginning. I add x_ to mine so the default filters stay at the top of the pop-up menu, where they're more easily spotted.

Figure 6.26 To save a custom filter setting as a preset, click the Custom Filter button.

Figure 6.27 In the pop-up menu, choose "Save Current Settings as New Preset."

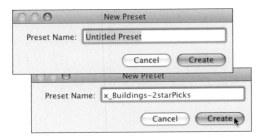

Figure 6.28 Name your custom filter and click Create.

Figure 6.29 The Preset is added to the Custom Filter list. Activate it by selecting it in the pop-up menu.

```
    Default Columns
    Filters Off
    Flagged
    Location Columns
    Rated
    Unrated
✓  x_Alaska_landscapes_starred
    x_Buildings-2starPicks

    Save Current Settings as New Preset...
    Delete preset "x_Alaska_landscapes_starred"...
    Rename preset "x_Alaska_landscapes_starred"...
```

Figure 6.30 To delete a Custom Filter preset, click the Custom Filter pop-up menu and choose Delete.

To delete a Custom Filter preset:

1. In the Library Filter toolbar, click the Custom Filter pop-up menu and choose the preset you wish to delete. The preset is selected as the current custom filter.

2. Click the Custom Filter pop-up menu again, and choose Delete preset "name of your preset" (**Figure 6.30**). When the alert dialog box appears, click Delete. The preset is removed from the pop-up menu.

To rename a Custom Filter preset:

1. In the Library Filter toolbar, click the Custom Filter pop-up menu to choose a preset. The preset is selected as the current custom filter.

2. Click the Custom Filter pop-up menu again, and choose Rename preset "name of your preset." When the rename dialog box appears, type in a new name and click Rename. The name of the preset is updated in the pop-up menu.

USING THE LIBRARY FILTER

Even More Metadata Finds

Lightroom offers so many more ways to find your photos, it could take another book to explain them all. Here, however, are two especially handy ones using metadata:

◆ When working in the Keyword List panel, roll your cursor over the number at the right end of a keyword and press the arrow that appears (**Figure 6.31**). Lightroom activates the Library Filter's Metadata toolbar and displays every photo using the keyword (**Figure 6.32**).

◆ When working in the Metadata panel, click the arrow to the right of the Capture Time field, and Lightroom fetches every photo taken that day (**Figure 6.33**). Not every arrow in the Metadata panel works this way, so mind your clicks.

Figure 6.31 In the Keyword List panel, roll your cursor over the number at the right end of a keyword and press the arrow that appears...

Figure 6.32 ...and Lightroom displays every photo using the keyword.

Figure 6.33 In the Metadata panel, click the arrow to the right of the Capture Time field, and Lightroom fetches every photo taken that day.

Figure 6.34 Collections make it easy to generate multiple groups tailored to your viewing needs.

Creating and Using Collections

The Library Filter works well for one-time or occasional searches for particular photos. In contrast, collections are great for creating more permanent groups of photos you expect to view regularly. A collection might include photos of the same event, location, or keywords. Collections also can contain photos scattered among multiple folders. That means collections offer you a much more selective view than Lightroom's other view options of a *single* folder or *all* your photographs (**Figure 6.34**).

While a photo resides in a single folder, collections allow you to have multiple pointers to that photo, similar to shortcuts on Windows machines or aliases on Macs. Since collections are just pointers, and not copies of the photos, they take up very little hard drive space. So a single photo taken during the Mojave Desert's spring wildflower bloom could belong to all these collections: Spring, Wildflowers, and Deserts. Collections also make it easy to maintain a portfolio of your best work, no matter how your folders and hard drives are organized.

When you're manually gathering photos, you can build your collections using a temporary Quick Collection or a Target Collection, a new feature that works quite similarly. The great thing about both is how easy they make it for you to quickly mark photos for collections. Using the B and forward arrow keys, you can rip through the Grid view or Filmstrip marking photos as you go. A Quick Collection is often the easiest way to start marking photos for what will become a regular collection later on.

Smart Collections, new in Lightroom 2, automatically generate collections of photos based on rules you create. As you import new photos into Lightroom, Smart Collections use those rules to update their contents. To get you started, Lightroom includes five pre-built Smart Collections, which help give you a sense of how useful they can be (**Figure 6.35**).

Figure 6.35 Lightroom includes five pre-built Smart Collections.

If none of those features turns you into a collection user, consider this: You can create collections tied to Lightroom's various modules. For example, you can set up—and preserve—a Slideshow collection with exactly the layout and overlays you want (**Figure 6.36**).

As you inevitably create more collections, you can arrange them into collection sets, which you can expand or collapse as needed in the Collections panel.

Collection sets help organize collections

Library module collection

Print module collection

Rules auto-update Smart Collections

Collection set nested inside a collection set

Slideshow module collection

Web module collection

Define your own Smart Collections

Figure 6.36 You can create collections tied to Lightroom's various modules.

Figure 6.37 When you add a photo to a Quick Collection, a note appears briefly confirming your action.

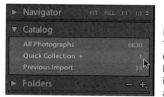

Figure 6.38 The Quick Collection lists how many photos it contains as you add photos.

Figure 6.39 Add images to a Quick Collection by rolling the cursor over an image until a small circle appears in the upper-right corner.

Figure 6.40 Click the circle and an Add to Quick Collection note appears briefly.

Figure 6.41 The small white circle turns grey, indicating the image is now part of the Quick Collection.

To add to a Quick Collection one photo at a time:

1. Using the Grid view or Filmstrip, click on a photo you want to add to a Quick Collection.

2. Press the B on your keyboard.

 or

 Right-click (Control-click on a Mac) and choose Add to Quick Collection in the drop-down menu.

3. An Add to Quick Collection note appears briefly, and the image is added to your Quick Collection (**Figures 6.37, 6.38**).

✔ Tips

■ You can only have a single Quick Collection at any one time. But the Quick Collection persists until you deliberately empty it, so you can build it over the course of several computer sessions if necessary.

■ In the Grid view or Filmstrip, you can rapidly add images to the Quick Collection by selecting the first image, pressing the B on your keyboard, pressing the forward arrow to move to the next image, pressing the B again if you want to add that one, or pressing the forward arrow again to move to the next image. Your hands never leave the keyboard, so it's possible to efficiently sift through many images.

■ If Badges are set to show in the Grid view (View > Grid View Style > Show Badges), you can add images to a Quick Collection by rolling the cursor over an image until a small circle appears in the upper-right corner (**Figure 6.39**). Click the circle and an Add to Quick Collection note appears briefly (**Figure 6.40**). The small white circle turns grey, indicating the image is now part of the Quick Collection (**Figure 6.41**).

CREATING AND USING COLLECTIONS

109

To add multiple images to a Quick Collection:

1. Using the Grid view or Filmstrip, select the photos you want to add to a Quick Collection.

2. Right-click (Control-click on a Mac) and choose Add to Quick Collection in the pop-up menu (**Figure 6.42**).

 or

 Click and drag the selected images to the Quick Collection listing in the Catalog panel (**Figure 6.43**).

 or

 From the Menu bar, choose Photo > Add to Quick Collection.

3. The selected photos are added to the Quick Collection, updating the number of photos listed in the Quick Collection listing in the Catalog panel (**Figure 6.44**).

✔ Tip

- If you're using the Filmstrip and working in the Slideshow, Print, or Web modules, step 2's last option would be *Edit* > Add To Quick Collection.

Figure 6.42 To add multiple images to a Quick Collection, select them and choose Add to Quick Collection in the pop-up menu.

Figure 6.43 You also can click and drag the selected images to the Quick Collection listing in the Catalog panel.

Figure 6.44 The Quick Collection's photo count updates as you add more photos.

Figure 6.45 To remove images from a Quick Collection, select them, and choose Remove from Quick Collection in the pop-up menu.

Figure 6.46 You also can remove photos from the Quick Collection by rolling the cursor over the grey circle in a photo's upper-right corner.

Figure 6.47 Click the circle and a Remove from Quick Collection note appears briefly.

To remove image(s) from a Quick Collection:

1. Using the Grid view or Filmstrip, select the photos you want to remove from the Quick Collection.

2. Right-click (Control-click on a Mac) and choose Remove from Quick Collection in the pop-up menu (**Figure 6.45**). The images are removed from the Quick Collection, as reflected in the image count in the Catalog panel.

 or

 Roll the cursor over the grey circle in the upper-right corner of a single image (**Figure 6.46**). Click the circle and a Remove from Quick Collection note appears briefly (**Figure 6.47**). The small gray circle disappears, indicating the image is no longer part of the Quick Collection (**Figure 6.48**).

Figure 6.48 The small gray circle disappears, indicating the image is no longer part of the Quick Collection.

CREATING AND USING COLLECTIONS

To save a Quick Collection as a regular collection:

1. In the Catalog panel, right-click (Control-click on a Mac) the Quick Collection and in the pop-up menu choose Save Quick Collection (**Figure 6.49**).

2. Type a name for your collection in the Collection Name textbox, leave the checkbox selected, and click Save (**Figure 6.50**). When the Save Quick Collection dialog box closes, the new collection appears in the Collections panel (**Figure 6.51**). The Quick Collection is empty once again.

✔ Tip

■ In step 2, if you do not select "Clear Quick Collection After Saving," you will not be able to create a new Quick Collection until you manually clear the collection (see next page).

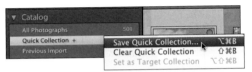

Figure 6.49 To save a Quick Collection as a regular collection, right-click (Control-click on a Mac) the Quick Collection listing and choose Save Quick Collection.

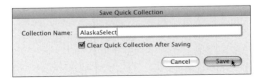

Figure 6.50 Name your collection in the Collection Name textbox, leave the checkbox selected, and click Save.

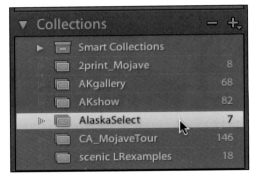

Figure 6.51 The new collection is listed in the Collections panel.

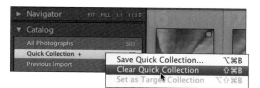

Figure 6.52 To empty a Quick Collection, right-click (Control-click on a Mac) the Quick Collection listing and choose Clear Quick Collection.

Figure 6.53 The Quick Collection empties, and the count resets to 0.

To empty a Quick Collection:

◆ In the Catalog panel, right-click (Control-click on a Mac) the Quick Collection listing and choose Clear Quick Collection in the pop-up menu (**Figure 6.52**). The Quick Collection empties, and the count resets to 0 (**Figure 6.53**). You now can create a new Quick Collection if desired.

To create a collection:

1. Switch to the module on which the collection should be based, such as Slideshow. Select the photos that you want to make into a collection (**Figure 6.54**).

2. In the Collections panel, click the + (plus) pop-up menu and choose Create Collection (**Figure 6.55**).

 or

 Use the keyboard shortcut: (Ctrl-N/ Cmd-N)

3. In the Create Collection dialog box, type in a descriptive name (**Figure 6.56**). Make sure "Include selected photos" is selected and click Create.

 Lightroom's main window displays the new collection and it's added to the Collections panel list (**Figure 6.57**). If you used a filter to gather the collection, notice that None is now highlighted, confirming you no longer need to run the filter to see these photos.

✔ Tips

■ In gathering photos for a collection, you can use the Library Filter including, as in Figure 6.54, a custom filter. Just be sure to choose All (Ctrl-A/Cmd-A) before proceeding to step 2.

■ When your Catalog > All Photographs setting shows a large number of photos, it may be faster to select a single folder and gather photos there for a collection. Once added to the collection, it's easy to switch to another folder and repeat the process.

■ All your collections remain visible in the Collections panel, no matter what module you use to create a collection. Double-click a collection in the panel and Lightroom switches to the module where it was created.

Figure 6.54 To create a collection, start by selecting photos. In this case, it contains the results of the custom filter created on page 104.

Figure 6.55 Then click the + (plus) pop-up menu and choose Create Collection.

Figure 6.56 Give the collection a descriptive name, choose "Include selected photos," and click Create.

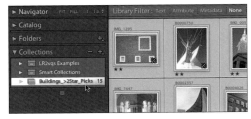

Figure 6.57 The main window displays the new collection, and it's added to the Collections panel list.

Figure 6.58 To delete a collection, right-click (Control-click on a Mac) it in the Collections panel and choose Delete.

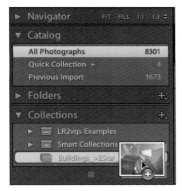

Figure 6.59 To add to a collection, drag and drop the selected photos to the collection listing.

To delete a collection:

◆ In the Collections panel, right-click (Control-click on a Mac) a collection you no longer need and choose Delete (**Figure 6.58**). The collection is removed from the Collections panel list.

To add to a collection:

◆ Make sure the Collections panel is visible, select photos you want to add to the collection, and drag and drop them to the collection listing (**Figure 6.59**). The number of photos listed for the collection changes to reflect the additions.

✔ Tip

■ You also can add to a collection by marking it as a so-called Target Collection (see next page).

Using a Target Collection

Lightroom's new Target Collection feature works almost identically as a Quick Collection. Unlike a Quick Collection, however, which requires you to transfer to a collection and then clear its contents, a Target Collection can be tied to *any* collection with an easy turn on/turn off action. The more collections you have, the more you will find yourself using the Target Collection feature to add to them.

To set a Target Collection:

1. Right-click (Control-click on a Mac) a collection listed in the Collections panel and choose Set as Target Collection in the pop-up menu (**Figure 6.60**).

2. In Lightroom's main window, select the photo(s) you want to add to the Target Collection and then take one of the same actions that are available when adding to a Quick Collection:

 Press the B on your keyboard.

 or

 Right-click (Control-click on a Mac) and choose Add to Target Collection in the drop-down menu.

 or

 Roll your cursor over an image until a small circle appears in the upper-right corner (**Figure 6.61**). Click the circle and an Add Photo to Target Collection note appears briefly. The small white circle turns grey, indicating the image is now part of the Quick Collection.

3. The photo(s) are added to the Target Collection.

Figure 6.60 To set a Target Collection, right-click (Control-click on a Mac) a collection in the Collections panel and choose Set as Target Collection.

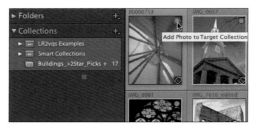

Figure 6.61 Roll the cursor over an image until a small circle appears in the upper-right corner. Click the circle and a confirming Add Photo to Target Collection note appears briefly.

✔ Tips

■ In the Collections panel, the Target Collection is marked with a + (plus) at the end of the collection's name (Figure 6.61).

■ You can only target one collection at a time. But you can quickly set another collection as the target.

■ As with a Quick Collection, using the Grid view or Filmstrip, you can rapidly add images to the Target Collection by selecting the first image, pressing the B on your keyboard, pressing the forward arrow to move to the next image, pressing the B again if you want to add that one, or pressing the forward arrow again to move to the next image.

CREATING AND USING COLLECTIONS

To turn off a Target Collection:

◆ Find the Target Collection in the
Collections panel; it's marked with a +
(plus). Right-click (Control-click on a
Mac) the Target Collection and choose
the already checked Set as Target
Collection in the pop-up menu (**Figure
6.62**). The + mark disappears, signal-
ing that the Target Collection has been
turned off (**Figure 6.63**).

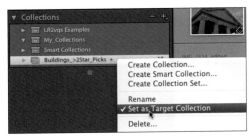

Figure 6.62 To turn off the Target Collection, right-click
(Control-click on a Mac) it in the Collections panel and
choose the already checked Set as Target Collection.

Figure 6.63 The + mark disappears, signaling that the
Target Collection has been turned off.

Figure 6.64 To create a collection set, click the + (plus) in the Collections panel and choose Create Collection Set.

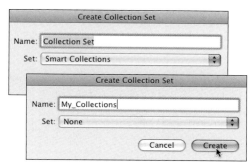

Figure 6.65 Give the set a descriptive name, change the Set pop-up menu to None, and click Create.

Figure 6.66 The new collection set, marked with a shoebox icon, is added to the Collections panel list.

To create a collection set:

1. As you create more collections, it helps to group them into sets. In the Collections panel, click the + (plus) and choose Create Collection Set in the pop-up menu (**Figure 6.64**).

2. In the Create Collection Set dialog box, type in a descriptive name. Change the Set pop-up menu to None and click Create (**Figure 6.65**).

 The new collection set, with an icon like a little shoebox, is added to the Collections panel list (**Figure 6.66**).

CREATING AND USING COLLECTIONS

119

To make a collection part of a set:

1. Click a collection in the Collections panel and drag it onto a collection set (**Figures 6.67, 6.68**).

2. Release the cursor and the selected collection becomes part of the collection set (**Figure 6.69**).

✔ Tip

■ You can create collection sets within collection sets.

Figure 6.67 To make a collection part of a set, select it and...

Figure 6.68 ...drag and drop the collection onto a collection set.

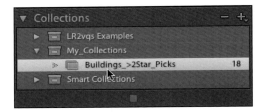

Figure 6.69 The selected collection becomes part of the collection set, indicated by an indented listing.

Figure 6.70 To create a Smart Collection, click the + (plus) in the Collections panel, and choose Create Smart Collection.

Figure 6.71 After naming your Smart Collection, set the Match menu, and use the left-hand drop-down menu to begin creating your first rule. Use the second drop-down menu to expand or narrow the first choice's search.

Figure 6.72 When you're done adding rules, click Create.

Figure 6.73 The Smart Collection is added to the Collections panel.

To create a Smart Collection:

1. In the Collections panel, click the + (plus) and choose Create Smart Collection in the pop-up menu (**Figure 6.70**).

2. In the Create Smart Collection dialog box, type in a descriptive name. Use the Set pop-up menu to choose None or an existing collection set.

3. Use the Match pop-up menu to set whether "all" or "any" of the rules you are to create must be met (see Tip).

4. Much as you did in setting the Library Filter metadata searches, use the first drop-down menu—you have 34 choices!—to begin creating your first rule (**Figure 6.71**). Use the second drop-down menu to expand or narrow the first choice's search.

5. To add another rule, click the + (plus) again. (Or click the - (minus) to remove a rule.) When you're done adding rules, click Create (**Figure 6.72**). The Smart Collection is added to the Collections panel list (**Figure 6.73**).

✔ Tip

■ In step 3, setting Match to "all" narrows your search, while choosing "any" expands the search.

To edit or rename a Smart Collection:

1. Right-click (Control-click on a Mac) any Smart Collection listed in the Collections panel, and choose Edit Smart Collection or Rename (**Figure 6.74**).

2. Use the Edit Smart Collection dialog box to change the collection's rules or its name. When you're done, click Save to close the dialog box and apply the edits.

✔ Tip

■ In step 1, you can choose to export a Smart Collection as a catalog, which you could store on another hard drive for safe keeping (**Figure 6.74**). You also can export/import the settings you created for a Smart Collection, which handily enables you to use those settings in another catalog.

Figure 6.74 To edit or rename a Smart Collection, right-click (Control-click on a Mac) a Smart Collection and make a choice in the drop-down menu.

7

DEVELOPING IMAGES

Developing images—adjusting their exposure, getting the colors just right, tweaking all the details—lies at the heart of photography. Lightroom has so many tools for doing just that, it can overwhelm even darkroom veterans. But the real joy of Lightroom, as you'll discover in this chapter, is how all the tools offer immediate *visual* feedback. You make an adjustment and you can see what's right or wrong about it. So don't let all the sliders, expanding panels, and myriad choices faze you. Lightroom actually makes the whole process fun.

Calibrate That Monitor

If you don't calibrate your monitor, you simply will not be able to produce reliable results—no matter how precisely you apply Lightroom's development adjustments. Software-only packages, such as the Mac's built-in Display Calibrator Assistant, fall short because they depend on our subjective sense of color, which varies from person to person. Hardware-software combinations, which include a device that attaches to the screen to read its light output, cost $100–$300. Some of the most popular are X-Rite's Eye-One series, Datacolor's Spyder series, and Pantone's hueyPro. What you save in bad color prints quickly makes up for the cost. (For more information, enter "monitor calibrate hardware" in your favorite Web search engine.)

Making Quick Fixes

With the right photo, the Quick Develop panel can work brilliantly (**Figures 7.1**, **7.2**). Other times it can make a so-so photo worse. Even when Quick Develop gets it wrong, it's easy to reverse an experiment gone wrong.

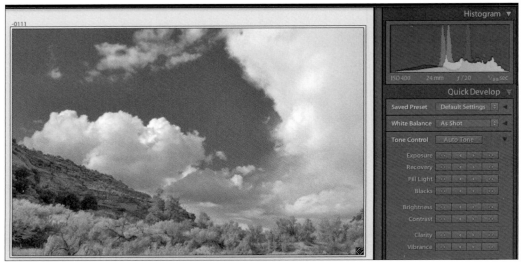

Figure 7.1 Sometimes, with the correct photo ...

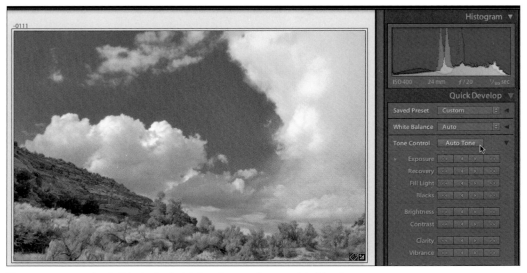

Figure 7.2 ... a couple of clicks in the Quick Develop panel can work brilliantly.

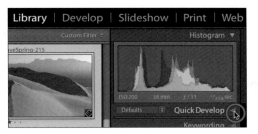

Figure 7.3 If the Quick Develop panel is collapsed, click the right-side triangle to expand it.

So it's often worth giving it a try. If the Quick Develop panel doesn't deliver what you need, Lightroom also has the full Develop panel.

The Quick Develop panel gives you fast access to almost all the tools found in the Develop mode. Reflecting its stripped down appearance, however, the Quick Develop versions do not offer the precise controls found in the Develop panel. As you gain experience with the Develop panel's effects, you actually may use the Quick Develop panel more often and with greater confidence. For that reason, this section offers a quick run-through of the Quick Develop controls, leaving the details to later sections highlighting the Develop module (page 129).

While initially it seems odd that Adobe put the Quick Develop panel in the Library module instead of the Develop module, the reason is that's where you review your shots. In sifting the good from the bad, sometimes a few quick clicks in the Quick Develop panel help you decide if a photo is worth more work later in the Develop module.

To apply Quick Develop adjustments:

1. Make sure the Histogram panel is expanded, since it helps you gauge the effects of any adjustments. If the Quick Develop panel is collapsed in the Library module, click the right-side triangle to expand it (**Figure 7.3**). Depending on whether the Quick Develop panel's been opened before, you may need to click each subpanel's right-side triangle to see all of the panel's options.

2. In the Grid view, select one or more photos you want to adjust.

(continues on next page)

MAKING QUICK FIXES

3. Each section of the Quick Develop panel uses a combination of drop-down menus or arrow buttons to make adjustments to the photo(s), which are applied immediately (**Figure 7.4**). The single arrow buttons boost or reduce an adjustment by five points out of 100. The double arrows apply 20 points of adjustment. You can adjust any of the following settings:

A **Saved Preset:** Use the drop-down menu to choose one of Lightroom's built-in develop adjustments, such as Creative-Sepia for an old-style appearance. If you have created any develop presets of your own, they also appear in the drop-down menu. (For more information, see "Using the Presets Panel" on page 130.)

B **Crop Ratio:** Use the drop-down menu to apply one of the common print proportions to the photo(s). (For more information, see "Using the Crop Overlay Tool" on page 156.)

C **Treatment:** The drop-down menu lets you quickly convert a photo from color to grayscale. (For a more complicated method that offers richer-looking results, see "Using the Grayscale and Split Toning Panels" on page 145.)

D **White Balance, Temperature, Tint:** Use the White Balance drop-down menu to apply a pre-set combination of temperature and tint to a photo. You also can use the individual Temperature and Tint buttons to create a custom white balance. (For more information on this and the remaining controls in this section, see "To apply basic adjustments" on page 136.)

E **Tone Control, Exposure, Recovery, Fill Light, Blacks:** Click the Tone Control button to apply an automatic combination of Exposure, Recovery, Fill Light, and Blacks. Or use the arrow buttons to individually apply any of the four controls. Unlike the rest of the Quick Develop buttons, the four controls use "stops" instead of 5- and 20-point steps. (See second Tip.)

F **Brightness, Contrast:** Even in small increments, the brightness and contrast controls are blunt instruments that affect the entire photo's appearance. Use the panel's Tone Control and Clarity sections instead, or switch to the Develop module for more precise results.

G **Clarity, Vibrance:** Clarity controls contrast in a photo's middle tones. Vibrance boosts or reduces color saturation in everything except skin tones.

4. If you are not happy with any adjustments, see "To undo Quick Develop adjustments" on page 128. As with all Lightroom adjustments, you don't need to perform a save command since all the adjustments are captured as metadata as you work.

✔ Tips

■ When using the single and double arrows to make adjustments, you can apply an in-between value—for example +15—by clicking a combination such as a double arrow (+20) and an opposing single arrow (−5).

■ If you're unfamiliar with the photographic term "stop" used in the Tone Control section, here's the gist: An *increase* of one stop *doubles* a setting's effect; a one-stop *decrease* reduces the effect by *half*. Also called "f-stops," they are a measure of how much light passes through an open lens. For example, a lens set at f/2 lets in *twice* as much light as one set at f/2.8. Moving in the other direction, a lens at f/1.4 lets in half as much light as one at f/2.

Figure 7.4 The Quick Develop panel offers quick access to major image adjustments.

MAKING QUICK FIXES

To undo Quick Develop adjustments:

◆ If you made *no* adjustments to the photo before starting the Quick Develop adjustments, click Reset All. The photo returns to how it looked before you began the Quick Develop work.

or

◆ If you want to undo only the adjustments you have made with a *single tool*, such as Tint or Brightness, click the tool's name next to the buttons. The photo returns to how it looked before you began using that particular tool.

or

◆ If you made lots of other adjustments to the photo *before* starting your Quick Develop work (crop, exposure, etc), use the Develop module's History panel. (See "To use the History Panel" on page 135.)

Working in the Develop Module

With the exception of the Library module's Quick Develop panel, most of your image adjustments are applied in the Develop module (**Figure 7.5**). The Left Panel Group contains the Presets, Snapshots, and History panels. The Right Panel Group contains eight separate panels, of which the Histogram, Basic, Tone Curve, and Detail panels are the ones you'll use most often. All these panels apply what are known as *global adjustments*; that is, they affect the entire photo. Just below the Histogram panel runs Lightroom 2's new Tool Strip. With the exception of the cropping tool, the Tool Strip applies *local adjustments*. These adjustments affect only selected parts of the photo, which you select using masks and brushes. For coverage of the Tool Strip, see Chapter 8 on page 155.

Presets
Roll cursor over preset to preview in Navigator

Develop Module
Highlighted in Module Picker

Histogram
Updates in real time as adjustments applied

Tool Strip
Five tools let you crop, fix spots or red eye, apply gradient or brush adjustments.

Detail panel
Use to see effects of adjustments in Sharpening or Noise Reduction panels

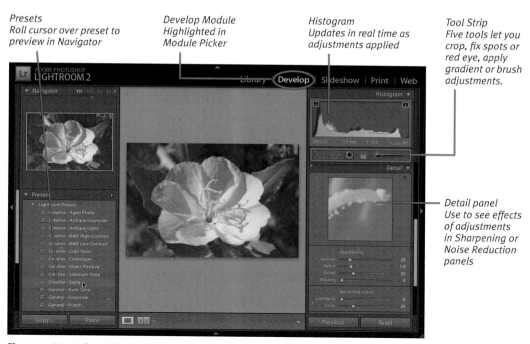

Figure 7.5 Most of your image adjustments are applied in the Develop module.

Creating Virtual Copies

As with the Library module's Quick Develop panel, you don't need to save your Develop module work since every adjustment is stored as metadata. But Lightroom includes a handy way of making *virtual* copies of your photo. These virtual copies make it easy to compare a photo with one set of adjustments against another version that uses a different set of adjustments. As with everything in Lightroom, these virtual copies are metadata, so they don't hog space on your hard drive.

To make a virtual copy of a photo:

1. In the Filmstrip or Grid view, select a photo (or several photos) of which you want to make a virtual copy.

2. Right-click (Control-click on a Mac) the photo(s) and choose Create Virtual Copy/ Create Virtual Copies in the drop-down menu (**Figure 7.6**). A copy of the selected photo appears next to the original (master) photo and is marked by a turned over left corner (**Figure 7.7**).

Figure 7.6 To make a virtual copy of a photo, right-click (Control-click on a Mac) the photo(s) and choose Create Virtual Copy/Create Virtual Copies in the drop-down menu.

Figure 7.7 A copy of the selected photo appears next to the original photo and is marked by a turned over corner.

Figure 7.8
Roll your cursor over the list of Presets and the Navigator offers a preview of each preset's effect.

Using the Presets Panel

Lightroom's 18 built-in Develop presets include many of the adjustments you are most likely to need. Preview them in the Presets panel to see what's possible before you even touch the Develop mode's Right Panel Group. They also provide handy starting points for creating your own just-so development settings, which you can then save in the User Presets section of the Presets panel.

To preview and apply a Develop preset:

1. Using the Library module's Grid or Loupe view, select the photo you want to adjust.

2. Switch to the Develop module and open the Navigator and Presets panels in the Left Panel Group.

3. Roll your cursor over the list of Presets and the Navigator offers a preview of each effect (**Figure 7.8**). When you find a Preset you like, click it in the list and the effect is applied to the photo.

To create a Develop preset:

1. In the Develop mode, apply any effects you want to a photo.

2. When you have a combination of settings that you might want to apply later to another photo, click the + (plus) in the Presets panel (**Figure 7.9**).

3. When the New Develop Preset dialog box appears, name the new preset, leave the folder set to User Presets, and select only the effects you want made part of the preset (**Figure 7.10**). Click Create to close the dialog box, and the new preset is added to the User Presets section of the Presets panel (**Figure 7.11**).

✔ Tip

- In step 3, give your preset a name that precisely describes its effect. "Nice vignette" will not mean much three months from now, while "vignette(–100,24midpt)" remains obvious.

Figure 7.9
When you have a setting you might want to apply later to another photo, click the + (plus) in the Presets panel.

Figure 7.10 Name the new preset and select only the effects you want made part of the preset.

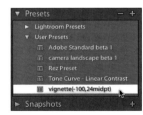

Figure 7.11 The new preset is added to the Presets panel.

Figure 7.12 To delete a Develop preset, select the Preset in the panel and click the – (minus).

To delete a Develop preset:

◆ Select the Preset in the panel you want to delete and click the – (minus). The Preset is removed from the list (**Figure 7.12**).

Using the Snapshot and History Panels

The Snapshot and History panels work like time machines by enabling you to get back to a particular spot in your sequence of applying develop adjustments. As you apply a long series of development adjustments, it can be handy to take "snapshots" when you like the results so far. If you want to retrace your steps, you can jump right back to one of those snapshots.

The History panel records in sequence every adjustment you make and enables you to rewind the process step-by-step. While found within the Library module, the panel can also be used to reverse course when a Quick Develop adjustment goes awry.

To use the Snapshots panel:

1. To capture the development adjustments currently applied to a photo, expand the Snapshots panel in the Develop module's Left Panel Group.

2. Click the + (plus) (**Figure 7.13**). Name the listing that appears in the Snapshots panel and press Enter/Return to add it to the Snapshots list (**Figure 7.14**).

3. To apply this snapshot's settings to a photo at any time, click its name in the Snapshots panel.

Figure 7.13
Click the + (plus) to create a new snapshot.

Figure 7.14 Name the listing and press Enter/Return to add it to the Snapshots list.

Figure 7.15
Roll your cursor over the History list to see how the photo's appearance changes in the Navigator panel.

To use the History panel:

1. To roll back a photo's adjustment in either the Develop mode or the Library module's Quick Develop panel, open the Develop module's Navigator and History panels.

2. The most recent adjustments to the photo are listed at the top of the History panel. Roll your cursor over the list, watching how the photo's appearance changes in the Navigator panel (**Figure 7.15**).

3. When you find a setting you like, click it in the list and those adjustments are restored to the photo. You can then resume your work in the Develop module's Right Panel Group or switch back to the Library module's Quick Develop panel.

USING THE SNAPSHOT AND HISTORY PANELS

Making Basic Adjustments

You'll make the majority of your development adjustments in the Basic panel, which controls three key aspects of any photo: its color balance, its tone, and its presence. If you have already used the Library module's Quick Develop panel, you got a taste of what the three do. However, you'll find that the Develop module gives you much finer control over their settings. In most cases, Lightroom's panels and the tools within them are arranged with the first-to-use adjustments at the top and the last-to-use at the bottom. You can use them in any order you like, but top to bottom generally yields the most consistent results.

To apply basic adjustments:

1. Make sure the Histogram panel (A) is expanded to help you gauge the effects of any adjustments. If the Basic panel is collapsed, click the right-side triangle to expand it (**Figure 7.16**).

2. Open the Filmstrip and select a photo you want to adjust. In Lightroom's main window, click the Y|Y button in the lower left to set which Before and After view you want to use (**Figure 7.17**). Lightroom's main window presents a before and after version of the photo, which helps gauge the effect of the adjustments (**Figure 7.18**).

3. Use any of the Basic panel's (B) controls, whose adjustments are applied immediately as you move the sliders:

 C **Treatment:** To convert a photo from color to black-and-white, click the Grayscale button. (For a more complicated method that offers richer-looking results, see "Using the Grayscale and Split Toning Panels" on page 145.)

 D **WB (White Balance): Temperature, Tint:** With many of today's digital cameras, you can leave the WB drop-down

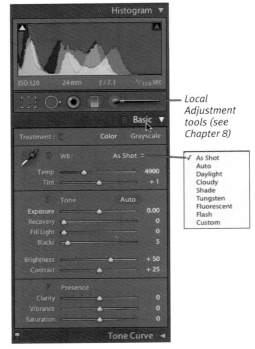

Local Adjustment tools (see Chapter 8)

Figure 7.16 Make sure the Histogram panel (A) is expanded to help you gauge the effects of any adjustments made in the Basic panel.

Figure 7.17 Click the Y|Y button to set which Before and After view you want to use.

Figure 7.18 The before and after versions of the photo help you gauge the effect of adjustments.

MAKING BASIC ADJUSTMENTS

Figure 7.19 Click the White Balance panel's eyedropper and use it to find a color-neutral white or gray in the photo.

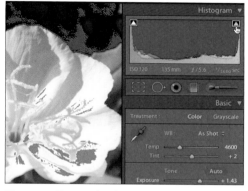

Figure 7.20 Turn on the clipping indicators in the top corners of the Histogram. Areas without highlight details are red; blacks without detail are blue.

Figure 7.21 You can adjust the tones by click-and-dragging left or right within the Histogram.

menu set to the default of As Shot. If the camera's auto white balance was turned off, however, use the drop-down menu to choose a more appropriate setting (Shade, Fluorescent, Flash, etc.). If your photo contains several light sources of different colors (flash being bluer than daylight for example), you may need to create a custom setting. To do so, click the panel's eyedropper and move it over your photo to a color-neutral white or gray, indicated when the floating panel's R-G-B values are roughly equal (**Figure 7.19**). (It doesn't matter if all three read 30 or 90 percent as long as the values are about the same.) When you find the point, click the eyedropper and a custom white balance is applied. (For another approach, see "Syncing White Balance" on page 140.)

E **Tone: (Auto), Exposure, Recovery, Fill Light, Blacks:** Begin by turning on the clipping indicators in the top corners of the Histogram (**Figure 7.20**). Areas in the photo where details are being lost in the highlights turn red, while blacks without detail turn blue. Clipping also appears in the Histogram when the graph line is cut off (clipped) on the right or left sides. While you can click the Auto button to apply an automatic combination of Exposure, Recovery, Fill Light, and Blacks, you'll have more control applying each individually, using the sliders or click-and-dragging left or right within the Histogram (**Figure 7.21**). Adjust the Exposure first, followed by Recovery. Then set the Blacks before adjusting Fill Light. Use Brightness and Contrast only for a finishing touch. (See "Doing the Tone Dance" on the next page.)

(continues on next page)

MAKING BASIC ADJUSTMENTS

F **Presence: Clarity, Vibrance, Saturation:** Use the Clarity control to adjust *midtone* contrast. It works a bit like Photoshop's unsharp mask by increasing contrast along edges. Like unsharp mask, it carries the risk of generating halos if applied too strongly, so use judiciously. You also can apply negative Clarity for a slightly diffused effect. Adjusting Saturation affects *all colors* across the entire photo, while Vibrance effects just the *less saturated colors.* This lets you boost duller colors without sending already saturated areas off the chart. It's particularly valuable for keeping skin tones from turning too red-orange.

Doing the Tone Dance

It takes a while to get a sense of how the Tone subpanel's adjustment tools affect each other, especially the Exposure-Recovery combination and, to a lesser degree, Blacks and Fill Light. The great thing is you can reshuffle your steps again and again because all the adjustments are made using nondestructive metadata.

Let Exposure lead Recovery: Pay attention to the photo's *overall* exposure first. While you are trying to spread the values more evenly across the Histogram, let your eyes be the primary judge not the graph. Don't worry yet about highlight clipping—that's done with the Recovery adjustment. If a Recovery value of 100 (full right) is not enough to bring back all the highlights, you need to readjust the Exposure to the left. Over time, you'll come to understand how dark to set Lightroom's Exposure control up front, knowing that Recovery can rescue many of the highlights.

Follow with Blacks, some Fill Light: Compared with the to and fro of Exposure and Recovery, the relationship between Blacks and Fill Light is more straightforward. Unless you're photo-graphing a polar bear in a snowstorm, you want some pure blacks in an image to give it some punch. So set the Blacks adjustment to *slightly* clipped (seldom more than 15). Use the Fill Light adjustment to rescue the shadow detail. Then—and only then—*lightly* tweak the Brightness and Contrast controls to nudge your midtone values. Or instead consider boosting the Clarity adjustment slightly.

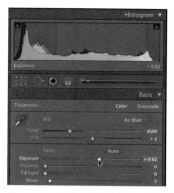

Figure 7.22 Make the Right Panel Group as wide as possible, and the adjustment sliders can be moved with more precision.

Working with the Histogram

Different photo subjects generate very different histograms. The top histogram shows a relatively high contrast subject with lots of blacks and highlights (**Figure 7.23**). The bottom histogram shows a subject dominated by midtones. You can "correct" a histogram so that it has a virtually even distribution of blacks, shadows, midtones, and highlights—and rob it of all its original drama. The point is there is no "ideal" histogram. It entirely depends on the subject—and the mood you want the photo to convey.

Figure 7.23 The top histogram shows a relatively high-contrast subject with lots of blacks and highlights. The bottom histogram shows a subject dominated by midtones.

✔ Tips

■ If you make the Right Panel Group as wide as possible (about 370 pixels), the Basic panel's adjustment sliders can be moved with more precision (**Figure 7.22**). (This trick works for any slider in any module.)

■ If turning on the clipping indicators proves too distracting, you can press Alt/Option while adjusting the Exposure, Recovery, or Blacks slider. Using that method, only the clipped areas appear on screen.

■ In step 3, the Tone controls do a good job correcting the overall exposure of JPEG photos. However, raw images by nature contain much more exposure data, and what Lightroom can do with them often approaches the miraculous. That's why pro-level cameras—and increasingly pro-sumer models as well—use the raw format.

■ You can use Lightroom's Sync button to copy any or all of your Develop adjustments to another photo. Though "Syncing White Balance" on page 140 uses only a single adjustment, the process is the same.

MAKING BASIC ADJUSTMENTS

Syncing White Balance

Rather than adjust a photo's white balance using the method explained in step 3 on page 136, some photographers use a neutral gray card, a pre-light meter trick that remains useful in a world gone digital. By snapping a photo of the card in the *same light* striking the subject, you can create an absolute reference point to use in Lightroom.

1. In the Develop module's Filmstrip, select two photos: *first* the one containing the gray card, and *then* the other of the subject shot in the same light (**Figure 7.24**). This sequence makes the photo of the card the *active* photo of the two selected (**A**). The active photo appears in Lightroom's main window (**B**).

2. Click the eyedropper in the top-left corner of the White Balance section of the Basic panel (**C**). Your cursor becomes an eyedropper. Move the eyedropper into the photo and click to sample the card's neutral gray area (**D**).

3. Click the Sync button at the bottom of the Right Panel Group (**Figure 7.25**).

4. White Balance should be the only item selected in the Synchronize Settings dialog box (**Figure 7.26**). Click Synchronize to close the dialog box and apply the setting to the other photo selected in step 1. You can double check if the setting was applied by selecting that photo and expanding the History panel (**Figure 7.27**). The same process can be used to apply adjustments in one photo to one (or more) other photos.

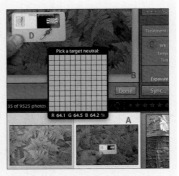

Figure 7.24 Make the photo with the gray card your active photo in the Filmstrip (**A**), and it also appears in the main window (**B**). Click the top-left circle in the White Balance panel (**C**) to activate the eyedropper tool and sample the card's neutral gray (**D**).

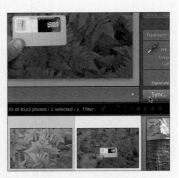

Figure 7.25 After sampling the card, click the Sync button at the bottom of the Right Panel Group.

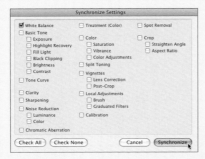

Figure 7.26 White Balance should be the only item selected in the Synchronize Settings dialog box. Click Synchronize to close the dialog box and apply the setting to the other photo selected at the beginning.

Figure 7.27 The white balance for the other photo is synchronized to the gray card in the first photo, as you can see when you expand the History panel.

MAKING BASIC ADJUSTMENTS

 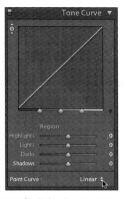

Figure 7.28 The Tone Curve panel's Point Curve, set to Medium Contrast by default, provides a starting point for your adjustments (left). Set to Linear (right), the Point Curve contains no tweaks to lighten or darken any particular areas.

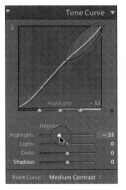 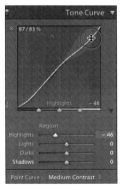

Figure 7.29 Click the Tone Curve panel's Highlights slider (left) or click directly on the curve (right), and the graph shows which part of the curve will be changed.

Adjusting Tone Curves

The Point Curve pop-up menu, at the bottom of the Tone Curve panel, provides a starting point for your adjustments. By default, it's set to Medium Contrast, which, as the curve shows, slightly lightens the highlights while slightly darkening the shadows (left, **Figure 7.28**). Linear, as the name implies, is a straight line with no tweaks to lighten or darken any particular areas (right, **Figure 7.28**). Strong Contrast boosts the milder effects of Medium Contrast.

The Tone Curve panel includes a nice feedback feature for adjusting the curve: Roll the cursor over the Highlights slider and the graph spotlights which section of the curve will be affected (**Figure 7.29**). Better still, it even shows you the maximum and minimum changes you can apply to that section. The other three sliders behave the same way. Compared with Photoshop's somewhat cryptic curve controls, Lightroom's make it much easier to puzzle out how to best adjust the curve. The Target Adjustment tool is particularly helpful, since it lets you click directly in the photo and adjust the curves for a particular area—without even messing with the Tone Curve panel's sliders.

To adjust the tone curve:

1. Select the photo you want to adjust. In Lightroom's main window, click the Y|Y button in the lower left to set which Before and After view you want to use. Lightroom's main window presents a before and an after version of the photo to help you gauge the effect of the adjustments.

2. Leave the Point Curve setting at the bottom of the Tone Curve panel on Medium Contrast, unless you prefer the Linear or Strong Contrast setting.

3. Start by adjusting the Highlights, using one of three methods: adjust the Highlights slider, click and drag the Highlights section of the tone curve graph, or click the Target Adjustment tool and then click on a highlights section within the photo (**Figures 7.29–7.30**). Adjust as needed. If you want to start over, double-click the Highlights label and the setting returns to zero.

4. Repeat the process as needed for the Lights, Darks, and Shadows.

✔ Tips

■ If you want to change the range of adjustment affected by each of the four Tone Curve sliders, move the three Tone Range Split Point controls at the bottom of the graph. As with the other controls, double-click any split point to return it to its original setting.

■ The Tone Curve panel has a toggle switch, enabling you to see the photo with and without all of that panel's adjustments applied (**Figure 7.31**). This switch is available in all the Develop module's right-hand panels, except for the Basic panel.

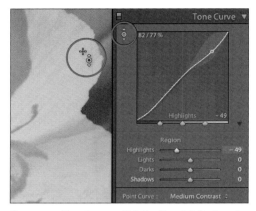

Figure 7.30 You also can click the Target Adjustment tool and then click in the photo to adjust the highlights.

Figure 7.31 The Tone Curve panel has a toggle switch that lets you see the photo with and without the adjustments applied.

Using the HSL and Color Panels

Both the Hue and Color panels control the selected photo's hue (color range), saturation (intensity), and luminance (darkness/lightness). But each panel is organized a bit differently, so it's a matter of preference as to which one you use. As with the Tone Curve panel, the Hue panel gives you the option of making adjustments with a slider or a Target Adjustment tool, which you can click and then adjust that aspect directly in the photo. The Color panel offers only sliders. The Grayscale panel is best used in conjunction with the Split Toning panel, as explained on page 145.

To adjust the HSL controls:

1. The HSL panel organizes the colors by each one's Hue, Saturation, and Luminance. By default, the panel shows all three aspects. If you want the panel to be a bit less sprawling, select one of the color labels at the top of the panel to see just the Hue, Saturation, or Luminance section for that color alone (**Figure 7.32**).

2. Within the desired section, use the slider to adjust one of the eight color ranges. If necessary, you can choose another color range to adjust after finishing the first.

 or

 Click the Target Adjustment tool for the active section (Hue, Saturation, or Luminance) to turn it on. Then click directly in the photo on the color range you want to adjust. Drag the tool up or down to increase or decrease the selected aspect. Lightroom automatically selects the correct color range slider in the panel and applies the adjustment (**Figure 7.33**). You can click on another area of the photo, and Lightroom automatically switches to the correct color range slider. When you are done making an adjustment, click the Target Adjustment tool to turn it off, or click another section's Target Adjustment tool to make other adjustments.

To adjust the Color controls:

1. In the Color panel, select All to see every color range or click a single color range label for a less cluttered panel (top, **Figure 7.34**).

2. Choose which aspect you want to adjust (Hue, Saturation, or Luminance) by clicking and dragging its respective slider (bottom, **Figure 7.34**). When done, you can choose another color range label and make adjustments to it.

Figure 7.32 To toggle the HSL panel to a simplified view, click one of the labels: Hue, Saturation, or Luminance.

Figure 7.33 Using the Target Adjustment tool, you can click directly in the photo, drag up or down, and Lightroom automatically adjusts the correct color range slider.

Figure 7.34 If you don't want to see all 24 sliders in the Color panel, click one color (top). The panel collapses to show only the sliders for that color (bottom).

Using the Grayscale and Split Toning Panels

When you shoot with black-and-white film, or use a digital camera's "black-and-white effect" setting, all the colors in the scene are mapped to various tones of gray. Once you take the photo, you can't convert it back to color. You also cannot precisely adjust which colors mapped to which tones of gray. With Lightroom, however, you can shoot in color, convert the scene to grayscale, and adjust that sky so that it's a light airy gray or a dark dramatic gray. Then, if you don't like the results, you can convert that photo *back* to color just by clicking the HSL or Color labels in the HSL/Color/Grayscale panel.

When working with grayscale photos, Lightroom gives you two options that you can use alone or in combination (**Figure 7.35**). The first option lets you adjust which colors are mapped to which gray tones. This is done in the Grayscale section of the HSL/ Color/Grayscale panel. The second option, found in the Split Toning panel, lets you apply a particular color to a photo's highlights and shadows. Called split toning, this old dark-room chemical technique has gone digital. Warm sepia and bluish cyanotype photos are the best known examples. The Presets panel, explained on page 131, enables you to apply these and other effects with a single click. To create your own custom split tones, see "To apply split toning" on page 148.

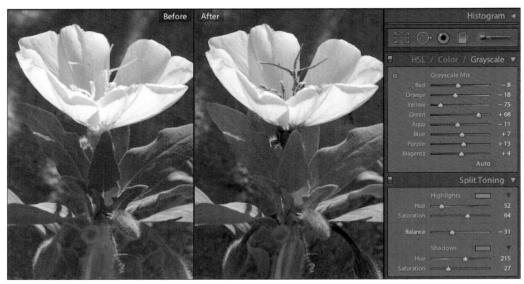

Figure 7.35 In creating grayscale photos, Lightroom enables you to adjust which colors map to which tones of gray, as well as apply split tones to the highlights and shadows.

Figure 7.36 To create a grayscale photo, expand the HSL/Color/Grayscale panel and click the Grayscale label.

Figure 7.37 Use any of the eight sliders to darken or lighten the grays mapped to that color.

To create and adjust a grayscale photo:

1. Adjust the photo's exposure in the Basic panel beforehand. In Lightroom's main window, click the Y|Y button in the lower left to set which Before (Color) and After (Grayscale) split you want to use.

2. Expand the HSL/Color/Grayscale panel and click the Grayscale label. The photo's colors immediately switch to gray tones, and each of the eight color sliders is set to a specific level (**Figure 7.36**).

3. As in the Tone Curve panel, click the Target Adjustment tool and then click and drag in the photo on an area whose tone you want to darken (minus) or lighten (plus). The eight sliders update to reflect the adjustment.

4. To apply more adjustments, click in a different area of the photo. Or click and drag a single color slider. You can judge the results in part by comparing the color and grayscale versions. Once you are done, click the Target Adjustment tool again to turn it off (**Figure 7.37**).

5. Select another photo to which you want to apply grayscale adjustments. Or click the + (plus) in the Snapshots panel to create a return point before continuing by applying a split tone to the photo (see next page).

To apply split toning

1. Select a photo that you have already converted to grayscale and expand the Split Toning panel (**Figure 7.38**).

2. Click the box just right of the Highlights label to open the Highlights panel (**Figure 7.39**).

3. To select a color to apply to the photo's highlights, roll the cursor (which becomes an eyedropper), over one of the colored boxes or anywhere in the color spectrum box. Click to sample the color, which is applied immediately to the photo's highlights (**Figure 7.40**).

4. Click and drag the Highlight panel's S slider to change the chosen color's saturation, or click another color you like better. When you're done, click the top-left X to close the Highlights panel. If you are happy with the results, you can stop after applying the single tone.

5. To apply a second tone to the photo's shadows, click the box to the right of the Shadows label in the Split Toning panel.

6. Roll the cursor, which becomes an eyedropper, over one of the colored boxes or anywhere in the color spectrum box. Click to sample the color and it is applied immediately to the photo's shadows.

Figure 7.38 To apply split toning, start with a photo you have already converted to grayscale and expand the Split Toning panel.

Figure 7.39 Click the box just right of the Highlights label to open the Highlights panel.

Figure 7.40 Click to sample a color, which is applied immediately to the photo's highlights.

Figure 7.41 Click and drag the S slider to change the saturation applied to the photo's shadows.

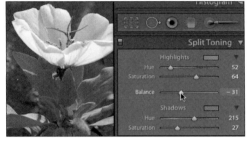

Figure 7.42 After applying both tones, use the Balance slider to adjust the point where the shadow tone gives way to the highlight tone.

7. Click and drag the S slider to change the chosen color's saturation, or click another color you like better (**Figure 7.41**). When you're done, click the top-left X to close the Shadows panel.

8. Once you apply both tones, use the Split Toning panel's Balance slider to adjust the dark-to-light point where one tone should give way to the other (**Figure 7.42**).

✔ Tips

■ After creating a particular highlight or shadow tone, you can save it in the Highlights or Shadows panel. Select the color in one of the panels, then click and hold your cursor on one of the five color boxes to replace that old color.

■ To get a better feel for how the color choices and saturations affect a photo's appearance, apply one of the Presets panel's effects and look at the settings generated in the Split Toning panel.

Using the Detail Panel

The Detail panel does exactly what its name suggests: Lets you see a photo's individual pixels *without* blocking your overall view of a photo. The panel contains tools for three tasks that especially benefit from this see-the-trees-and-the-forest view: sharpening, noise, and chromatic aberration.

Around since the earliest days of Photoshop as the Unsharp Mask filter, sharpening tools find the edges in a photo and boost the contrast along them. Done right, you don't know it's being used. Done wrong and you wind up with halos and edges craggier than a cliff. How much you sharpen depends on the photo obviously, but there are general rules as well. JPEG photos are automatically sharpened some by the camera. Raw files are untouched by the camera and, so, usually need some sharpening. In addition to the sharpening applied here in the Develop module's Detail panel, Lightroom's Slideshow, Print, and Web modules can apply sharpening tailored to each of the three media.

"Noise" in digital photography is the equivalent of grain in film photography. It's usually caused by shooting a scene with the camera set with an ISO of 200+. Generally, the more expensive the camera, the better it is at suppressing noise. (Though most often using a tripod or flash will do the job for fewer bucks.) Sometimes you may like the noise effect; many times you want to reduce its visibility as much as possible. The Noise Reduction section has two tools to do this. One suppresses the luminance differences (darkness, lightness) within the noise. The other suppresses the color differences. Take some time to experiment with both tools to discover which works best for individual photos.

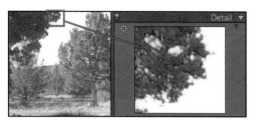

Figure 7.43 Chromatic Aberration is most noticeable where a section of sky meets another object.

Figure 7.44 Right-click (Control-click on a Mac) the Detail panel window to make sure you are zoomed to at least 1:1.

Figure 7.45 Press Alt/Option while dragging the Sharpening panel's Amount slider, and you will see a grayscale version of the photo, which can make it easier to judge the effect.

As for Chromatic Aberration, while many photographers have noticed it in close-ups of their outdoor photos, they call it by another name: purple fringing. An artifact of how your lens bends light, Chromatic Aberration is most noticeable where a section of sky meets another object (**Figure 7.43**).

To adjust sharpening:

1. After selecting the photo to adjust, click the cross-hair in the Detail panel's top-left corner and then click in the photo on the problem area. The panel's close-up window zooms to that area. Right-click (Control-click on a Mac) the window to make sure you are zoomed to at least 1:1 before starting (**Figure 7.44**).

2. The Detail pane's Sharpening section has four sliders (**Figure 7.45**). By default, the Amount slider is set to 25. To adjust the effect, which is often likened to a volume control, press Alt/Option while dragging the slider. The zoom window shows a grayscale version of the photo, which can make it easier to see the effect.

(continues on next page)

USING THE DETAIL PANEL

3. By default, the Radius slider is set to 1 with a maximum of 3 (pixels). To fine-tune the effect's pixel width, press Alt/Option while dragging the slider. The zoom window shows a grayscale version of the photo, which can make it easier to see the effect (**Figure 7.46**). The effect is smoother if the Radius is set no higher than 1.

4. By default, the Detail slider is set to 25. To adjust the effect, which controls the photo's apparent texture, press Alt/Option while dragging the slider. The zoom window shows a grayscale version of the photo, which can make it easier to see the effect (**Figure 7.47**).

Figure 7.46 To fine-tune the Radius adjustment, press Alt/Option while dragging its slider.

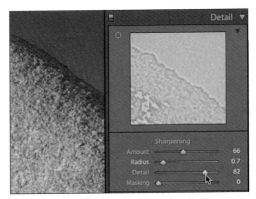

Figure 7.47 The Sharpening panel's Detail adjustment controls the photo's apparent texture.

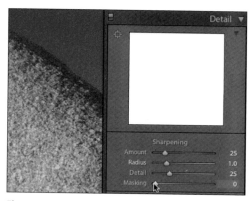

Figure 7.48 Masking works like an overlay that controls the collective effect of the Amount, Radius, and Detail sliders. At zero, the mask is off and solid white, so it's *not* blocking the other three sliders.

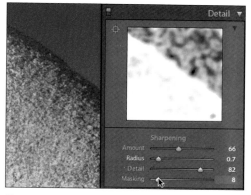

Figure 7.49 With the slider set low, Masking is applied broadly across the image. Gray areas let through *some* of the effects of the other three sliders. Black lets none through.

5. By default, the Masking slider is set to 0 (zero). Masking works like an overlay that controls the collective effect of the other three sliders. At zero, the mask is *off* and solid *white*, which means it's *not* blocking the other three sliders (**Figure 7.48**). At 100, the masking is fully *on* and solid *black*, completely *blocking* the effects of the other three sliders. To adjust the masking between those extremes, press Alt/Option while dragging the slider. The zoom window shows the mix of white, which lets the effects of the other sliders show through, and black, where those effects are blocked. Like a smoky window, the gray areas let some of the other three effects show through (**Figures 7.49, 7.50**).

6. Having set all four sliders, you may need to readjust some of them to get the overall sharpening effect you want.

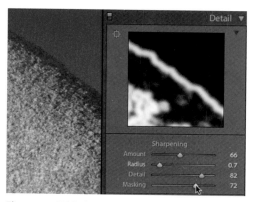

Figure 7.50 With the slider set high: Masking is applied to very limited areas. Gray areas let through *some* of the effects of the other three sliders. Black lets none through.

To adjust noise:

1. After selecting the photo to adjust, click the cross-hair in the Detail panel's top-left corner and then click in the photo on the problem area. The panel's close-up window zooms to that area (left, **Figure 7.51**).

2. The Detail panel's Noise Reduction section has two sliders. Click and drag the Luminance (Darkness/Lightness) and/or Color sliders while watching the panel's close-up window. More often that not, only one of the tools needs to be used (right, **Figure 7.51**). Pushing either slider to the far right reduces the photo's crispness, so you may need to go back to the Sharpening section to readjust the overall appearance.

To adjust chromatic aberration:

1. After selecting the photo to adjust, click the cross-hair in the Detail panel's top-left corner and then click in the photo on the problem area. The panel's close-up window zooms to that area (**Figure 7.52**).

2. The Detail panel's Chromatic Aberration section has two sliders, plus the Defringe pop-up menu. Use the menu to choose: Off (the default), Highlight Edges (best for where extreme highlights meet darker objects such as a sky background), or All Edges. If that fixes the problem, you are done. If not, try step 3.

3. Click and drag the Red/Cyan and/or Blue/Yellow sliders while watching the panel's close-up window. You may need to readjust both sliders several times to find the best combination.

Figure 7.51 Left: Before any noise reduction. Right: The Luminance slider does most of the work in this example.

Figure 7.52 To reduce lens Chromatic Aberration (color fringing), start by making a choice in the Defringe pop-up menu.

MAKING LOCAL IMAGE ADJUSTMENTS

Crop Overlay (R) Adjustment Brush (K)

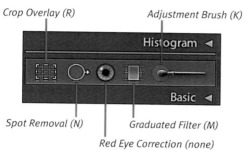

Spot Removal (N) Graduated Filter (M)

Red Eye Correction (none)

Figure 8.1 New in Lightroom 2, the Tool Strip houses five tools, shown here with their keyboard shortcuts.

Just below the Histogram panel resides Lightroom 2's new Tool Strip (**Figure 8.1**). With the exception of the Crop Overlay tool, the Tool Strip is used to apply *local adjustments*. These adjustments affect only certain parts of a photo, which you select. Clicking each of the five tools reveals a set of adjustments related to the particular tool. Considered the most exciting addition in Lightroom 2, these local adjustment tools finally give digital photographers an easy-to-use digital equivalent to the dodge and burn tools of chemical darkrooms.

Using the Crop Overlay Tool

The Crop Overlay tool isn't really a local adjustment. After all, what's more global than a crop? Still, its placement in the Tool Strip makes it easy to find and use. Like everything else in Lightroom, the adjustments are stored as metadata. That means you can redo or undo the crop at any time.

To crop a photo:

1. Select the photo you want to crop or straighten and click the Crop Overlay tool (R) to reveal its related adjustments (**Figure 8.2**). A set of eight adjustment handles appears along the perimeter of the photo.

2. Do any of the following:

 To crop to a specific ratio, use the drop-down menu to choose a common print-size proportion. An overlay appears based on your choice, which you can move to frame the crop (**Figure 8.3**).

 or

 To preserve the photo's original proportions, click the Lock button and then use the photo's handles or drag your cursor over the photo to frame the crop (**Figure 8.4**).

 or

 To crop freehand, click and drag in the photo. To frame the crop properly, use the photo's handles or reposition the overlay (**Figure 8.5**).

3. Press Enter/Return to apply the crop.

✔ Tip

■ Click the panel's Reset button whenever you want to start over applying a crop.

Figure 8.2 Click the Crop Overlay tool to reveal its related adjustments for cropping and straightening photos.

Figure 8.3 Use the drop-down menu to choose a common print-size proportion. An overlay appears, which you can move to frame the crop.

Figure 8.4 To preserve the photo's original proportions, click the Lock button. Then use the photo's handles or drag your cursor to frame the crop.

Figure 8.5 To crop freehand, click and drag in the photo. To frame the crop properly, use the handles or reposition the overlay.

Figure 8.6 Click one of the photo's corners and rotate the handle to level the photo.

Figure 8.7 Click in the photo on a level surface or the horizon. The cursor becomes a level, which you can use to draw a line to another point on the surface or horizon.

Figure 8.8 After you draw the level line, the photo is straightened.

Figure 8.9 Press Enter/Return to apply the straightening crop.

To straighten a photo:

1. Select the photo you want to straighten and click the Crop Overlay tool (R) to reveal its related adjustments.

2. Do any of the following:

 Click the panel's Angle slider and drag in either direction to level the photo. A more detailed grid overlay appears to guide you.

 or

 Click one of the photo's corners and rotate the handle that appears to level the photo. A more detailed grid overlay appears to guide you (**Figure 8.6**).

 or

 Click inside the photo on a level surface or the horizon. The cursor becomes a level, which you can use to draw a line to another point on the surface or horizon (**Figure 8.7**). After the second click, the photo is straightened (**Figure 8.8**).

3. Press Enter/Return to apply the straightening crop (**Figure 8.9**).

Using the Spot Removal Tool

The Spot Removal tool offers two powerful ways to fix blemishes and dust spots in your photos. The Clone Brush samples the pixels from another area of the photo and replaces those in the target area. The Heal Brush matches the texture and light of the area surrounding the spot, which makes for a seamless blend. Learning to manipulate the sampling of your source and target areas can seem a bit awkward initially. Take the time to learn, however, and you'll never look back.

To remove spots:

1. Select a photo and press the Z on your keyboard to zoom in on the spot you want to remove or repair. Or use the Zoom slider if it's visible (**Figure 8.10**).

2. Click the Spot Removal tool (N) to reveal its related adjustments (**Figure 8.11**).

3. Click to select the Clone or Heal brush.

4. Click in the photo on the spot you want to remove (**Figure 8.12**). A second spot appears, which marks the *source* of the sample used for the repair (**Figure 8.13**).

Figure 8.10 Zoom in on the spot you want to remove or repair.

Figure 8.11 Click the Spot Removal tool (N) to reveal its related adjustments.

Figure 8.12 Click in the photo on the spot you want to remove and ...

Figure 8.13 ... a second spot appears, which marks the source of the sample to be used for the repair.

USING THE SPOT REMOVAL TOOL

Figure 8.14 Reposition each circle as needed and adjust the Size and Opacity sliders to get the best results.

Figure 8.15 If you need to make a larger repair, click on the part of the spot still visible and a second repair circle appears.

Figure 8.16 Reposition the repair source circle that appears and continue your repair.

5. Reposition each circle as needed and adjust the Size and Opacity sliders to get the best results (**Figure 8.14**). The fix is applied "live," so as you move the source spot, the targeted spot is updated.

6. If that does not repair the entire spot, click on the part of the spot still visible and a second repair circle appears (**Figure 8.15**).

7. As in step 5, reposition the repair source circle and continue the repair (**Figure 8.16**). Repeat as necessary to complete the cleanup/repair. When you finish, you can hide the panel by clicking its Close button.

✔ Tip

■ Click the panel's Reset button if you want to start over.

Using the Red Eye Correction Tool

The Red Eye Correction tool is essential for removing the ghoulish eyes created in flash photos. Its adjustment sliders allow you to precisely apply the correction.

To remove red eye:

1. Select the photo from which you want to remove red eye and click the Red Eye Correction tool to reveal its related adjustments (**Figure 8.17**). (There is no keyboard shortcut for this tool.)

2. Click on the center of one eye, and the cursor becomes a cross-hair (**Figure 8.18**). Drag the cursor toward the edge of the pupil, using the Pupil Size and Darken sliders to adjust as needed (**Figure 8.19**).

3. When you finish one pupil (**Figure 8.20**), you can repeat the process for the other pupil.

✔ Tip

■ Click the panel's Reset button whenever you want to start over.

Figure 8.17 Click the Red Eye Correction tool to reveal its related adjustments.

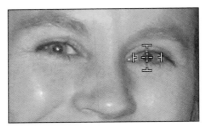

Figure 8.18 Click on the center of the eye's pupil, and the cursor becomes a cross-hair.

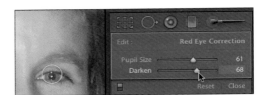

Figure 8.19 Drag the cursor toward the pupil's edge, using the Pupil Size and Darken sliders to adjust as needed.

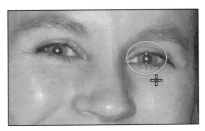

Figure 8.20 When you finish one pupil, repeat the process for the other pupil.

Figure 8.21 Before applying the Graduated Filter tool to bridge the differences between the sky and shadows.

Using the Graduated Filter

Landscape photographers will love Lightroom's Graduated Filter tool, which is perfect for shots where the difference between the sky and foreground shadows is often too great to expose properly in the camera. Whether you are adjusting for differences in exposure or any of seven other aspects, the filter lets you do it as subtly as you need. With the ability to apply multiple graduated filters, the difference between the before and after versions can be dramatic (**Figures 8.21, 8.22**).

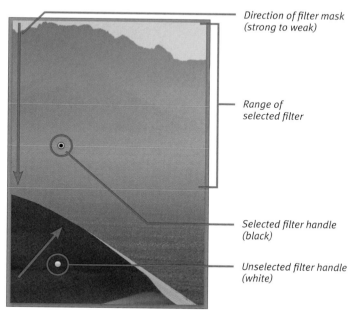

Direction of filter mask (strong to weak)

Range of selected filter

Selected filter handle (black)

Unselected filter handle (white)

Figure 8.22 After applying the Graduated Filter tool, the exposure extremes are reduced.

To apply a graduated filter:

1. Select a photo and click the Tool Strip's Graduated Filter (M) to reveal its related adjustments (**Figure 8.23**).

2. You can apply a single adjustment by choosing it in the Effect drop-down menu. Or apply multiple adjustments by moving each of the panel's six sliders.

3. Click and drag in the photo and three parallel lines show the extent of the graduated filter (**Figure 8.24**). Drag farther to apply the filter over a larger area, or reverse direction with your cursor to narrow the area affected by the filter.

4. Click and drag any of the three lines to adjust the distance between the filter's high, center, and low ranges (**Figure 8.25**). This compresses or expands the shift from one range to another.

5. To adjust the angle of a filter, click anywhere along the center line. The cursor becomes a double-headed arrow, which you can then pivot in either direction (**Figure 8.26**).

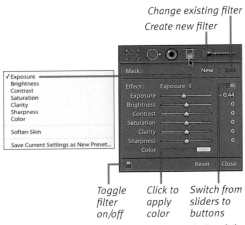

Change existing filter
Create new filter

Toggle filter on/off *Click to apply color* *Switch from sliders to buttons*

Figure 8.23 Click the Tool Strip's Graduated Filter (M) to reveal its related adjustments.

Figure 8.24 Three parallel lines show the extent of the graduated filter.

Figure 8.25 Click and drag any of the three lines to adjust the distance between the filter's high, center, and low ranges.

Figure 8.26 To adjust the angle of a filter, click the center line, and then pivot your cursor in either direction.

USING THE GRADUATED FILTER

Figure 8.27 To apply a color to the adjustments, click the Color patch and use the eyedropper in the Select a Color panel.

Figure 8.28 To remove a filter, select its adjustment pin and press Enter/Return. On the Mac, an animated puff of smoke signals its deletion.

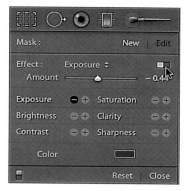

Figure 8.29 You can switch the panel's Graduated Filter tools from sliders to buttons.

6. If needed—and it usually is—readjust the panel's sliders to fine-tune the filter's effects. To gauge the filter's effects, click the bottom-left switch to turn the filter off and on.

7. You also can apply a color to the adjustments by clicking the Color patch and using the eyedropper in the Select a Color panel that appears (**Figure 8.27**). This works similarly to the Split Toning panel (see page 148). Click the X to close the panel.

8. To add a second filter, click the New button and begin the process again for another area of the photo.

9. To remove a filter, click its "adjustment pin" and the center of the pin turns black. Press Enter/Return and the adjustment is deleted. On the Mac, an animated puff of smoke marks the deletion (**Figure 8.28**).

10. To go back and adjust another filter, click its adjustment pin to select it before moving the sliders. The panel's Edit button becomes active.

✔ Tips

- In step 2, the Soften Skin effect in the drop-down menu works by applying a combination of Clarity and Sharpness adjustments.

- If you like, you can switch the panel's Graduated Filter tools from sliders to buttons with the click of a button (**Figure 8.29**).

- Click the panel's Reset button if you want to remove all the filters and start over.

Using the Adjustment Brush

Like the Graduated Filter, the Adjustment Brush gives you the ability to apply a variety of adjustments to precise areas of your photo. One obvious use is as a digital equivalent of the chemical darkroom's old dodge and burn tools. But as you learn to use the brush—and it does take some practice—you will discover that its many possible effects will take you far beyond that starting point.

To apply an adjustment brush:

1. Select a photo and click the Adjustment Brush tool (K) to reveal its related adjustments (**Figure 8.30**). The Mask section automatically selects the New setting.

2. Using the Effect drop-down menu, you can choose *one* of eight adjustments. Or you can apply *multiple* adjustments by moving any of the section's six sliders.

3. In the Brush section, where the A brush is selected by default, set its Size, Feather, and Flow. Use the slider to set the brush's Density, which is the brush stroke's transparency. (For information on using Auto Mask, see the last Tip on page 166.)

4. Once you've set the brush, click in the photo where you want to apply the effect and an "adjustment pin" is inserted to mark this set of brush strokes. Based on the brush mark made with your first click, you may want to fine-tune the Size and Feather before continuing (**Figure 8.31**).

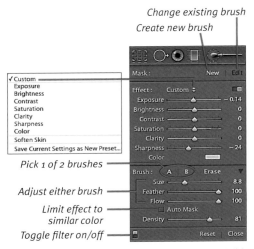

Change existing brush
Create new brush
Pick 1 of 2 brushes
Adjust either brush
Limit effect to similar color
Toggle filter on/off

Figure 8.30 Click the Tool Strip's Adjustment Brush (K) to reveal its related adjustments.

Figure 8.31 Based on the brush mark made by your first click, you may want to fine-tune the Size and Feather.

Figure 8.32 To see the extent of the mask being applied by the brush, roll the cursor over the adjustment pin.

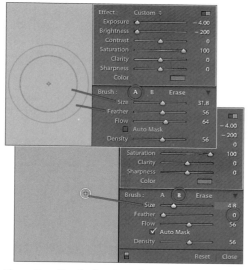

Figure 8.33 Use the Brush section's settings to adjust the B version of your A brush.

5. Begin "painting" with your cursor to apply the effect. You can adjust the effect for *all* the strokes associated with this first adjustment pin just by changing the panel's settings.

6. If you need to erase some strokes, click the panel's Erase button or press Alt/ Option. When the cursor becomes a - (minus) sign, paint over your brush mistakes.

7. To remove an entire set of brush marks, click that set's adjustment pin. The pin's center turns black to signal that it is selected. Press Enter/Return and the pin is deleted. On the Mac, an animated puff of smoke appears.

8. To see where the mask is being applied by the brush, roll the cursor over the adjust-ment pin (**Figure 8.32**). If you cannot find the pin, press H and it appears. (Press H again and the pin disappears.)

9. When applying the effect, you can create a different size brush by clicking the B in the Brush section. Use the Brush section's Size, Feather, Flow, Auto Mask, and Density set-tings to adjust the B version of your brush (**Figure 8.33**). Press / (slash key) to toggle between applying the A and B versions of the brush.

(continues on next page)

USING THE ADJUSTMENT BRUSH

10. To apply *another* effect, click New to create a whole new brush, which again can have a B variation if you like. As you work, you can adjust each set of already applied brush marks by selecting its controlling adjustment pin and changing the panel settings (**Figures 8.34, 8.35**).

✔ Tips

- In step 2, the Soften Skin effect in the drop-down menu works by applying a combination of Clarity and Sharpness adjustments. If you create a brush you may want to use again, choose Save Current Settings as New Preset in the drop-down menu and give it a name.

- In step 3, it can be useful to set one brush as a tool for burning (darkening) and the other as a dodge tool (lightening). That lets you quickly move from one exposure problem to another without fiddling with the brushes.

- In step 3, if you set the brush Flow and Density between 50 and 80, you can build the mask using light, multiple passes. Select Auto Mask if you want the brush's effect limited to areas of similar color.

- Selecting Auto Mask in step 3 applies the adjustments to the single color you select when first clicking within the photo. It is especially useful for isolating, and then changing, a background.

Figure 8.34 Three different Adjustment Brushes, using a mix of Exposure, Clarity, and Sharpness effects, were applied to different areas of the photo.

Figure 8.35 Before the Adjustment Brush was applied, the photo had some problem highlight and shadow areas.

CREATING SLIDESHOWS AND WEB GALLERIES

9

Lightroom's Slideshow and Web modules are good examples of why the program is far more than a photo organizing and retouching tool. Both modules give you lots of ways to customize how your photos are presented. Yet all those choices are not overwhelming because Lightroom's streamlined interface makes them easy to understand and use. In producing Web galleries for your Web site, Lightroom automatically generates all the necessary, behind-the-scenes coding. You do not need to know HTML or Adobe Flash to create galleries of clickable thumbnail images arranged on Web pages. Lightroom links the thumbnails to larger, higher quality images, and even guides you through the process of uploading all the photos and Web pages and photos to your Web site.

Selecting and Ordering Photos

Whether you are creating a slideshow or a Web gallery, you begin in the Library module. That's where you select the photos you want to use and arrange them in the order you want them to appear.

To select and arrange the order of photos:

1. In the Library module, use the Grid view or Filmstrip to select the photos you want to include in the slideshow or Web gallery.

2. Turn the selection into a collection, then select that new collection in the Collections panel. (For more information on creating collections, see page 107.)

3. To rearrange the order of the photos, you can use the Grid view or the Filmstrip. Click to select a photo and drag it to a new place in the photo order (top, **Figure 9.1**). Release the cursor and the order is rearranged (bottom, **Figure 9.1**).

4. Repeat until you have rearranged the photos in the order you want for the slide-show or gallery. You can fine-tune that order at any point later.

Figure 9.1 To rearrange the photos, click to select a photo and drag it to a new place in the photo order.

SELECTING AND ORDERING PHOTOS

Using the Slideshow Module

The Slideshow module is packed with options for presenting your photos onscreen, but you use it by following a series of simple-to-use panels. Select a pre-built template as a starting point and customize it using a variety of settings available in the Right Panel Group (**Figure 9.2**).

Roll cursor over templates to preview other styling choices

Main window shows Right Panel Group slide choices

Right Panel Group Panels for setting presentation borders, layout, backdrop, titles, and soundtrack

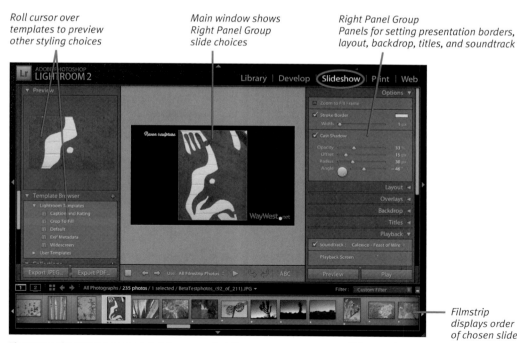

Filmstrip displays order of chosen slides

Figure 9.2 The Slideshow module lets you control the onscreen appearance, titling, and playback of your photos.

To choose a slide template:

1. Select a collection of photos you have already arranged in order and switch to the Slideshow module (**Figure 9.3**).

2. If the Filmstrip is not already visible, expand it by clicking the triangle at the bottom of Lightroom's main window. Also turn on the toolbar (press T on your keyboard), which will display slideshow-specific buttons (**Figure 9.4**).

3. In the Left Panel Group, expand the Template Browser panel (**Figure 9.5**). Roll your cursor over any of the slideshow templates to see it in the Preview panel. Click one of the six templates to apply it to your slideshow.

4. If you want to customize the template you have chosen, see "Choosing Slideshow Settings" on the next page.

Figure 9.3 The Slideshow module includes pre-built templates for presenting your photos.

Figure 9.4 In the Slideshow module, the toolbar displays slideshow-specific buttons. (Press T on your keyboard to show/hide it.)

Figure 9.5 Roll your cursor over any of the slideshow templates to see it in the Preview panel.

Figure 9.6
Use the Options panel settings to fill the frame with the photo, add a border, and/or create a shadow effect.

Figure 9.7 The Option panel's stroke and shadow settings in Figure 9.6 as they appear in Lightroom's main window.

Figure 9.8
Use the Layout panel settings to display guides that will help you position items.

Figure 9.9 With Show Guides selected in the Layout panel in Figure 9.8, all four guidelines appear in Lightroom's main window.

Choosing Slideshow Settings

The six basic slideshow templates included with Lightroom serve as starting points, although they do offer all you need for a basic slideshow. All the settings for creating your own customized templates can be found in the Right Panel Group's Options, Layout, Overlays, Backdrop, and Titles panels. (The Playback panel is covered on page 177.) As you select settings and adjust sliders in each panel, your choices appear immediately in Lightroom's main window, giving you a rough sense of the slideshow's appearance. At any point along the way, you can see how your choices look on the full screen by clicking the toolbar's Preview button. You can go back to any panel and change your choices at any time.

To choose slideshow settings:

1. To customize the basic slideshow template you chose on the previous page, start with the Options panel and work your way down through the Titles panel.

2. **Options:** Use the panel settings to fill the frame with the photo, add a border, or create a shadow effect (**Figures 9.6, 9.7**).

3. **Layout:** You can use the panel's guide settings to help you align any items you might apply in the Overlays panel, which is covered below (**Figures 9.8, 9.9**). Once you have positioned those items, if you like, you can turn off the guidelines for a less cluttered view.

(continues on next page)

4. Overlays: Use the panel settings to display an identity plate, a photo's star rating, or any text, such as a title or caption (**Figures 9.10**, **9.11**). The Opacity and Scale sliders let you adjust each item's transparency and size. Shadow settings can be applied to each item individually by selecting the item in the main window and then adjusting the panel's sliders. (For more on identity plates, see "Creating Identity Plates" on page 176.)

To specify which text option appears in the slide, click the toolbar's ABC button and make a choice in the drop-down menu that appears (**Figure 9.12**). You can apply more than one text item by using the hand-shaped cursor or grabbing one of the corner handles to move or resize each as needed (**Figure 9.13**). (For more information on adding captions and other metadata, see "Adding and Syncing Metadata" on page 101.)

Figure 9.10
Use the Overlays panel settings to display an identity plate, ratings, text overlays, and shadow effects.

Figure 9.11 The Overlays panel settings in Figure 9.10 as they appear in Lightroom's main window.

Figure 9.13 Use the hand-shaped cursor or grab one of the corner handles to move or resize the text as needed.

Figure 9.12 To specify which text option appears in the slide, click the toolbar's ABC button and make a choice in the drop-down menu.

Figure 9.14
To add custom text, type an entry in the text box next to the ABC button and press Enter/Return to display the text.

Figure 9.15
Use the Backdrop panel settings to apply a color wash and background color. It's best to not apply a background image at the same time.

Figure 9.16 The Backdrop settings for Color Wash and Background Color in Figure 9.15 as they appear in Lightroom's main window.

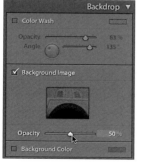

Figure 9.17
Use the Backdrop panel settings to apply a background image by dragging a photo from the Filmstrip onto the thumbnail frame. Use the Opacity slider to fade back the image.

or

You can create a label that appears in *every* photo in the slideshow. In the toolbar's drop-down menu next to the ABC button, choose Custom Text, type an entry into the text box that appears, and press Enter/Return to display the text (**Figure 9.14**). Reposition the results as needed in Lightroom's main window.

5. **Backdrop:** Use the panel settings to display a Color Wash and Background Color *or* a Background Image. To select a wash or background color, click the box to the right of each label and use the eyedropper in the dialog box that appears (**Figures 9.15**, **9.16**). To apply a background image, click a photo in the Filmstrip and drag it to the box in the panel (**Figures 9.17**, **9.18**). Adjust the Opacity slider to keep the viewer's focus on your main image.

6. **Titles:** Use the panel settings to display an Intro Screen and/or Ending Screen for your slideshow, including identity plates if you like. (For more information, see "Creating Identity Plates" on page 176.)

(continues on nex page)

Figure 9.18 The Backdrop panel settings as they appear in the main window after selecting Background Image in Figure 9.17 and turning off Color Wash and Background Color.

7. To create a *new* identity plate, select Add Identity Plate and choose Edit in the drop-down menu (**Figure 9.19**). Use the Identity Plate Editor to create new text or choose a graphic, then click Save As in the drop-down menu. Give it a name in the dialog box that appears, close that dialog box, and then click OK to close the Identity Plate Editor dialog box (**Figure 9.20**). Back in the Titles panel, select the new plate in the drop-down menu to use for an Intro or Ending screen (**Figure 9.21**). To see the Intro or Ending screens without running the slideshow, uncheck and then recheck the Add Identity Plate option (**Figure 9.22**). The screens appear briefly, enabling you to inspect them.

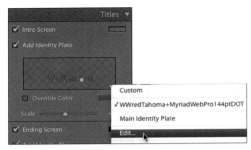

Figure 9.19 To create a *new* identify plate, select Add Identity Plate in the Titles panel and choose Edit in the drop-down menu.

Figure 9.20 Use the Identity Plate Editor to create new text or choose a graphic. Then choose Save As in the drop-down menu, and name it in the dialog box that appears.

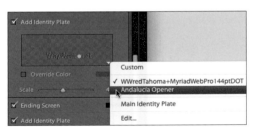

Figure 9.21 Back in the Titles panel, select the new plate in the drop-down menu to use for an Intro or Ending screen.

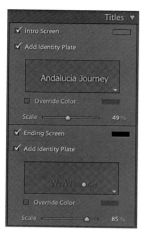

Figure 9.22
The Titles panel can be set to show different identity plates for the Intro and Ending screens.

8. Now you are ready to set the slideshow's playback, as explained in the next section.

✔ Tips

- If you turn on a text option, such as caption, and a particular photo does not have a caption, the Slideshow module's main window displays < empty >. However, that placeholder does not appear when actually running the slideshow, so you need not feel compelled to fill in captions for every photo in the show.

- While you are free in step 5 to apply a color wash, background image, *and* a background color, the results may well be a visual mess. The simpler the slideshow, the more likely viewers will focus on the photos.

Creating Identity Plates

By default, Lightroom displays its own Identity Plate in the top-left corner of every module. However, you can create your own identity plate using text or a graphic. Such plates can be especially handy in slideshows or printouts for highlighting your company's brand. To create an identity plate:

1. Choose Edit > Identity Plate Setup (Windows) or Lightroom > Identity Plate Setup (Mac).

2. In the Identity Plate Editor dialog box, select **A** to create a text-based plate or **B** to use a prepared graphic (**Figure 9.23**). For a text-based plate, type directly in the text window and style it using the Font, Style, and Size drop-down menus. For a graphic file, you can drag it directly into the text box. Or select Use a graphical identity plate, and, when the Locate File button appears, click it to navigate to the graphic.

3. When you have finished, click the drop-down menu at the top of the dialog box and choose Save As. Name your Identity Plate in the dialog box that appears and click Save.

4. To switch to your new Identity Plate, check Enable Identity Plate in the top-left corner (top, **Figure 9.24**). Your new Identity Plate immediately replaces Lightroom's default Identity Plate (bottom, **Figure 9.24**).

5. You can create multiple plates, saving each under a different name. When you are done, select the one you want to use in the top drop-down menu and click OK to close the Identity Plate Editor dialog box.

Figure 9.23 In the Identity Plate Editor dialog box, select **A** to create a text-based plate or **B** to use a prepared graphic.

Figure 9.24 To switch to your new plate, check Enable Identity Plate in the top-left corner (top). The new plate replaces Lightroom's default plate (bottom).

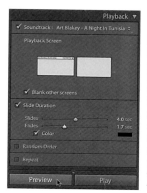

Figure 9.25
Use the Playback panel to choose background music (if any), set how long the slides play, and set what happens once all the slides are shown. If a second monitor is connected, you also can set which screen displays the slideshow.

Setting Slideshow Playback

Once you have sifted through all the slide-show settings, all that remains are the final steps of setting how the slideshow plays. Here is where you choose background music (if any), set how long the slides play, and set what should happen once all the slides are shown. Finally, you can export the whole show as a single file that others can watch on their own computers or stand-alone images for those who do not need a full-blown presentation.

To choose playback settings:

1. Use the panel's first drop-down menu if you want to choose a music file to use as a soundtrack (**Figure 9.25**).

2. If you are connected to a second monitor, use the Playback Screen section to select which screen displays the show. (See the Tip on the next page for more on screen choices.)

3. Use the panel's remaining sections to set how long each slide appears, how long it takes to fade to the next slide, and whether the photos play in random order and/or repeat at the end of the slideshow.

4. Press Preview to see how the slideshow looks in Lightroom's main window. You can go back and readjust any of your settings if necessary.

5. Once you are happy with the setup, press Play to run the full slideshow.

(continues on next page)

6. If you want to save all your slideshow settings as a single template, click the + (plus) in the Template Browser panel (left, **Figure 9.26**).

7. When the New Template dialog box appears, type in a name for your template, make sure the Folder is set to "User Templates," and click Create. The dialog box closes, and the new template is added to the Template Browser panel (right, **Figure 9.26**).

Figure 9.26 To save the slideshow settings as a template, click the + (plus) in the Template Browser panel (left). After the template is named and saved, it is added to the list of User Templates (right).

✔ Tip

■ You can use the main window and second window buttons in the Filmstrip to set how the slideshow is displayed. Options include running the slideshow fullscreen with the menu bar turned off or running it on both screens with the controls visible on only one machine.

SETTING SLIDESHOW PLAYBACK

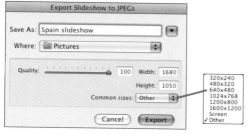

Figure 9.27
To export a slideshow, click Export JPEG (**A**) or Export PDF (**B**) at the bottom of the Left Panel Group.

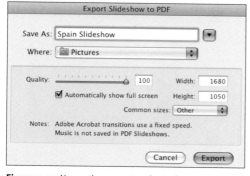

Figure 9.28 Name the export, select where you want it saved, and choose a quality and size for the multiple JPEG files generated.

To export a slideshow:

1. In the Slideshow module, click the Export JPEG (**A**) or Export PDF (**B**) button at the bottom of the Left Panel Group (**Figure 9.27**).

2. In either dialog box that appears (**Figure 9.28** and **Figure 9.29**), name the export and select where you want it saved. Set the quality using the slider and use the pop-up menu to choose among the common image sizes.

3. Click Export to start the export and close the dialog box. Lightroom displays several progress bars as it converts and saves the images.

4. The PDF is saved as a single file. If opened with Adobe Acrobat or Reader, the PDF will play as a slideshow, complete with transitions. The JPEG export creates a file for each image in the slideshow, which can be viewed as single images rather than a slideshow of multiple images.

✔ Tip

■ While you can export the slideshow for others to run on their computer or DVD player, the soundtrack cannot be exported.

Figure 9.29 Name the export, select where you want it saved, and choose a quality and size for the single PDF file generated.

Creating Web Galleries

Lightroom makes it easy to display your work on the Web in well-designed galleries that use either HTML or Adobe Flash (**Figure 9.30**). Building a gallery is very much like creating a slideshow, particularly since Lightroom automatically generates all the necessary coding behind the scenes. For example, each gallery automatically creates thumbnails of your photos that appear quickly when Web visitors surf around your site. If a visitor clicks a thumbnail, however, a larger, better-quality image will be downloaded.

Main window shows how album and buttons appear on Web site

Engine panel shows whether template based on Adobe Flash, HTML, or third-party package

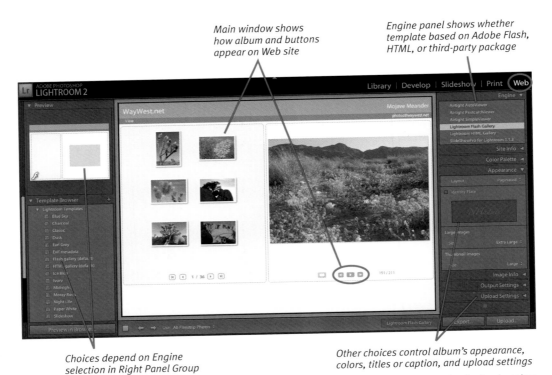

Choices depend on Engine selection in Right Panel Group

Other choices control album's appearance, colors, titles or caption, and upload settings

Figure 9.30 Pre-built Web gallery templates are listed in the Left Panel Group, which you can customize by choosing options in the Right Panel Group.

Figure 9.31 Begin by selecting a collection of photos that you have already arranged in order, then switch to the Web module.

Figure 9.32
Roll your cursor over any of the Web gallery templates to see its overall design in the Preview panel.

To choose a Web gallery template:

1. If the Filmstrip is not already visible, expand it by clicking the triangle at the bottom of Lightroom's main window. Also turn on the toolbar (press T on your keyboard), which will display Web gallery-specific buttons.

2. Select a collection of photos that you have already arranged in order and switch to the Web module (**Figure 9.31**).

3. In the Left Panel Group, expand the Template Browser panel. Roll your cursor over any of the templates to see its overall design in the Preview panel (**Figure 9.32**). In the Right Panel Group, the Engine panel tells you whether your template choice is based on Adobe Flash, HTML, or a third-party package such as Airtight Interactive.

4. Click a template choice to apply it to your photos. A progress bar appears briefly while the appropriate code is generated.

5. If you want to customize the template you have chosen, see "Choosing Web Gallery Settings" on the next page.

Choosing Web Gallery Settings

The Web gallery template you chose on the previous page serves as a starting point for creating your own customized template. All the settings for customizing the template reside in the Right Panel Group's Site Info, Color Palette, Appearance, Image Info, and Output Settings panels. (The Upload Settings panel is covered on page 185.)

To choose Web gallery settings:

1. To customize the basic Web gallery template you chose on the previous page, start with the Site Info panel and work your way down through the Output Settings panel. As you select settings, your choices appear immediately in Lightroom's main window. At any point along the way, you can see how your choices look by clicking the Preview in Browser button at the bottom of the Left Panel Group. You can go back to any panel and change your choices at any time.

2. **Site Info:** Expand the Site Info panel and fill in the text boxes whose information you want to use in your Web gallery, such as the Site Title or Collection Title (**Figure 9.33**).

3. **Color Palette:** Expand the panel and change the default color for any of the text or headers by clicking the adjacent color patch (**Figure 9.34**).When the Select a Color panel appears, you can choose another color using that panel's eyedropper.

4. **Appearance:** Expand the panel and use the pop-up menus to set how the Layout, Large Images, and Thumbnail Images appear. Select Identity Plate if you want to activate that option as well (**Figure 9.35**).

Figure 9.33
Use the Site Info panel to fill in the text boxes used in building the Web galleries.

Figure 9.34
Use the Color Palette panel to change the default color for any of the text or headers.

Figure 9.35 Use the Appearance panel's pop-up menus to set how the Layout, Large Images, and Thumbnail Images appear.

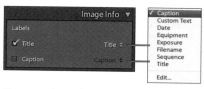

Figure 9.36 Use the Image Info panel to set whether you want any labels to be displayed; the two pop-up menus determine which two labels are used.

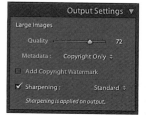

Figure 9.37
Use the Output Settings panel to control the quality for the gallery's large images, and set whether any metadata or sharpening is used.

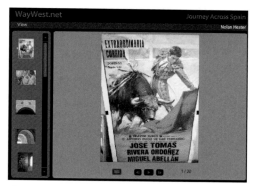

Figure 9.38 After choosing your gallery settings, you can see the overall look in Lightroom's main window.

5. **Image Info:** Expand the panel and set whether you want any labels to be displayed; the two pop-up menus determine which two labels are used (**Figure 9.36**).

6. **Output Settings:** Expand the panel and use the slider to control the quality for the gallery's Large Images. (Thumbnail images are not affected by this setting.) You also can choose to display such metadata as a copyright and have it appear as a light watermark within each gallery image. This somewhat reduces the likelihood of other Web sites downloading your images and using them as their own. The Sharpening setting should be left at Standard since Lightroom does a good job of fine-tuning sharpening to the given output (**Figure 9.37**).

7. After making all your choices in the gallery panels, take a good look at how your Web gallery looks in Lightroom's main window (**Figure 9.38**). Make any necessary adjustments. Now you are ready to set how the Web gallery is uploaded to your Web site, as explained in the next section.

Previewing and Uploading a Web Gallery

Once you choose all your Web gallery settings, you are ready to preview the gallery, then save its settings, and upload it to your Web site.

To preview and save a Web gallery:

1. In the Web module, click the Preview in Browser button at the bottom of the Left Panel Group (**Figure 9.39**). Or from the Menu bar, choose Web > Preview in Browser.

2. The Web gallery appears in your default browser, enabling you to test the various controls and views (**Figure 9.40**).

3. If you want to save your Web settings as a template, click the + (plus) in the Template Browser panel (left, **Figure 9.41**).

4. Type in a name for your template, make sure the Folder is set to "User Templates," and click Create. The new template is added to the Template Browser panel (right, **Figure 9.41**).

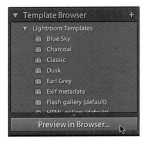

Figure 9.39
Click the Preview in Browser button to see how the gallery appears in your default Web browser.

Figure 9.40 When the Web gallery appears in your default browser, you can test the various controls and views.

Figure 9.41 To save your Web settings as a template, click the + (plus) in the Template Browser panel (left). After naming and saving the template, it is added to the list of User Templates (right).

Figure 9.42 To upload a Web gallery, click the FTP Server pop-up menu, and choose Edit.

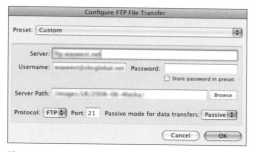

Figure 9.43 Enter the URL for your Web site's server, your username and password, and the Server Path, and then ...

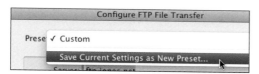

Figure 9.44 ... click the Preset drop-down menu and choose Save Current Settings as New Preset.

To upload a Web gallery:

1. Expand the Upload Settings panel, click the FTP Server pop-up menu, and choose Edit (**Figure 9.42**).

2. In the dialog box that appears, enter the URL for your Web site's server, the username you've been assigned, and the password (**Figure 9.43**). If you like, you can select "Store password in preset" and you will not need to enter it during future uploads. Type in the Server Path or, more likely, click Browse to navigate your way to the correct folder on the Web site. Leave the remaining settings as is, unless your administrator tells you otherwise.

3. Click the Preset drop-down menu at the top and choose Save Current Settings as New Preset (**Figure 9.44**).

4. Type in a name for your preset and click Create. Select your new preset in the Preset pop-up menu and click OK.

(continues on next page)

PREVIEWING AND UPLOADING A WEB GALLERY

5. In the Upload Settings panel, your new preset is selected as the FTP Server. Select Put in Subfolder and click the Upload button (**Figure 9.45**).

6. Enter your password in the dialog box that appears and click Upload (**Figure 9.46**). A progress bar tracks the upload (**Figure 9.47**).

7. When the upload finishes, use your Web browser to check that the files uploaded properly in the folder you specified.

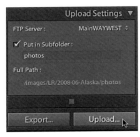

Figure 9.45 With your new preset selected as the FTP Server, click the Upload button. (The Put in Subfolder choice is optional, but makes for a tidier Web site.)

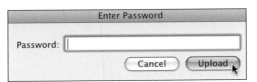

Figure 9.46 Enter your site's password and click Upload.

Figure 9.47 A progress bar tracks the upload. The length varies depending on the number of photos and their quality.

MAKING PRINTS

Despite Lightroom's slideshow and Web gallery options, many photographers still find that there's nothing quite like seeing photos as prints. Lightroom offers a rich array of printing choices within its Print module (**Figure 10.1**). But you also can start printing immediately using the module's pre-built templates.

Roll cursor over templates to see print layouts in Preview panel

Main window shows how selected prints flow on page

Right Panel Group choices set borders, rulers, and size-based sharpening

Figure 10.1 The Print module lets you set how photos lay out on a page. Pre-built templates run down the Left Panel Group, while the Right Panel Group offers ways to customize them.

Setting Up to Print

Begin by selecting which photos you want to print, arrange their order if appropriate, and choose what paper size to use.

To select photos to print:

1. In the Library module, use the Grid view or Filmstrip to select the photos you want to print.

2. Turn the selection into a collection, then select that new collection in the Collections panel. (For more information on creating collections, see page 107.)

3. Switch to the Print module.

✔ Tip

- If you plan to print several different images as part of a contact sheet or picture package, you can rearrange the order of the photos in the Filmstrip. Click to select a photo and drag it to a new place in the sequence.

To set the paper size:

1. In the Print module, click the Page Setup button at the bottom of the Left Panel Group (**Figure 10.2**).

2. In the Print Setup/Page Setup dialog box, make a choice from the Paper Size dropdown menu (**Figures 10.3**, **10.4**). Click OK to close the dialog box.

✔ Tip

- If you forget what size paper you are using, press I on your keyboard. An information overlay appears in the main window, listing the page number in the print layout, the paper size, and the selected printer (**Figure 10.5**). Press I again to hide the information.

Figure 10.2
To set the paper size, click the Page Setup button at the bottom of the Print module's Left Panel Group.

Figure 10.3 🖵 In the Print Setup dialog box, make a choice from the Paper Size drop-down menu.

Figure 10.4 🍎 In the Page Setup dialog box, make a choice from the Paper Size drop-down menu.

Figure 10.5
Press I on your keyboard to display the layout's page number, the paper size, and the selected printer.

Go to first print page

Previous Next print Page in
print page page sequence

Figure 10.6 Turn on the toolbar (press T on your keyboard) to display print-related buttons.

Figure 10.7
Roll your cursor over any of the pre-built templates to see its overall design in the Preview panel.

Choosing a Basic Print Template

Lightroom's 11 pre-built print templates can handle many of your basic print needs. All are based on either a Contact Sheet/Grid or Picture Package layout. The Contact Sheet/Grid templates arrange multiple *same-size* photos across one or more pages. The Picture Package templates—new in Lightroom 2—arrange multiple *different-size* photos on the same page.

To choose a print template:

1. Select a collection of photos that you want to print. Switch to the Print module and turn on the toolbar (press T on your keyboard). The toolbar will display print-related buttons (**Figure 10.6**).

2. In the Left Panel Group, expand the Template Browser panel. Roll your cursor over any of the pre-built templates to see its overall design in the Preview panel (**Figure 10.7**). Depending on your choice, Contact Sheet/Grid or Picture Package is highlighted in the Layout Engine panel.

3. Click a template choice to apply it to your photos (**Figure 10.8**).

(continues on next page)

Figure 10.8 Once you pick a pre-built template (in this case, the one in Figure 10.7), the main window shows it applied to your photos.

CHOOSING A BASIC PRINT TEMPLATE

4. If you are happy using one of the pre-built templates and are ready to print the photos, skip ahead to "Choosing Print Settings" on page 194. If you want to customize your chosen pre-built template, see "Customizing a Print Template" on the next page.

✔ Tips

■ By default, the main window displays horizontal and vertical rulers along the sides of the printer page. To turn them off or on, choose View > Show Rulers (Ctrl-R/Cmd-R).

■ Depending on your needs, you may want to display guides that indicate the page bleed, margins and gutters, or individual image dimensions. To turn the guides on or off, choose View > Guides and make your choices in the drop-down menu.

CHOOSING A BASIC PRINT TEMPLATE

Figure 10.9
To customize a print template, start by expanding the Image Settings panel.

Figure 10.10 Select Rotate to Fit whenever turning the photo makes for the better layout.

Figure 10.11 The Repeat One Photo per Page choice limits the layout to showing the *same* photo on each page, instead of *different* photos.

Customizing a Print Template

Once you pick a pre-built template as a starting point, you can customize it using the various settings in the Right Panel Group. The individual panels available vary depending on whether you start with a template using a Contact Sheet/Grid or Picture Package. (The last panel, Print Job, is covered on page 194.) You can go back and change your choices at any time.

To customize a print template:

1. To customize the pre-built template that you have chosen, start by expanding the Right Panel Group's Image Settings panel (**Figure 10.9**). Work your way down through the relevant panels, which vary depending on the pre-built template you selected. As you select settings, the print layouts in Lightroom's main window change immediately based on your choices.

2. **Image Settings:** Select the default settings you want to change (**Figure 10.10**). If you select Zoom to Fill, be aware that it will crop the image to fit the layout. Select Rotate to Fit if you need to turn the photo from horizontal to vertical (or vice versa) for a better layout. The Repeat One Photo per Page choice limits the layout to showing the *same* photo on each page, instead of *different* photos (**Figure 10.11**).

(continues on next page)

CUSTOMIZING A PRINT TEMPLATE

3. **Rulers, Grid & Guides:** This panel is available only when you use a Picture Package-based template. It simply lets you display rulers, grids, guides, the bleed/paper trim edges, and dimensions for the package photos (**Figure 10.12**).

or

Layout: This panel is available only when you use a Contact Sheet/Grid-based template (**Figure 10.13**). It controls the margins, page grid, cell spacing, and cell size of the overall layout. You can adjust the settings using the sliders or by clicking and dragging their lines within the main window.

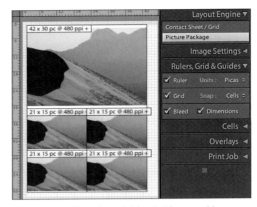

Figure 10.12 The Rulers, Grid & Guides panel is available only when you use a Picture Package-based template. It controls the display of rulers, grids, guides, bleed/paper trim edges, and dimensions for package photos.

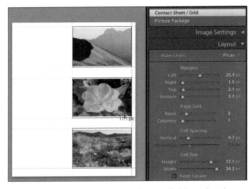

Figure 10.13 The Layout panel is available only when you use a Contact Sheet/Grid-based template. It controls the margins, page grid, cell spacing, and cell size of the overall layout.

Add a photo size to layout

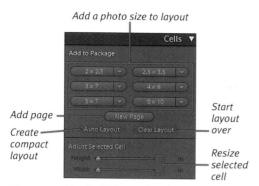

Add page

Create compact layout

Start layout over

Resize selected cell

Figure 10.14 Use the Cells panel to change the contents and layout of a Picture Package-based template.

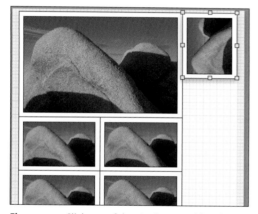

Figure 10.15 Click any of the six sizes to add a photo of that size to the layout.

Figure 10.16
The Overlays panel lets you add an identity plate with options to rotate it or adjust its size.

4. **Cells:** This panel is available only when you use a Picture Package-based template. (**Figure 10.14**). Use it to add photos and new pages to an existing package, rearrange the package layout, or clear the layout and start anew. Click any of the six sizes to add a photo of that size to the layout (**Figure 10.15**). As you add more photos, new pages are automatically added. If you click the Auto Layout button, Lightroom creates the most compact arrangement possible to save paper.

5. **Overlays:** This panel lets you add an Identity Plate to a Picture Package-based template only (**Figure 10.16**). Options include turning it 90 degrees, adjusting its opacity and size, and placing it partially behind the photos. If you use a Contact Sheet/Grid-based template, the panel includes options to add page numbers, crop marks, or such metadata as captions (**Figure 10.17**).

6. Double-check your choices and take a close look at the photos as they appear in Lightroom's main window. Once you are satisfied, choose your print settings as explained on the next page.

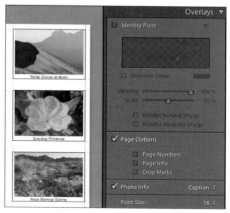

Figure 10.17 If you use a Contact Sheet/Grid-based template, the Overlays panel lets you add page numbers, crop marks, or such items as captions.

Choosing Print Settings

Before actually making prints, you need to set how Lightroom handles the job. Within the Print Job panel, you choose the print's resolution, how color management is handled, and how much (if any) sharpening is applied to the print.

To choose print settings:

1. Once you select your photos and choose either a pre-built or custom print template, expand the Print Job panel (**Figure 10.18**).

2. Select Draft Mode Printing if you want to print out something quickly, such as a contact sheet. Draft mode uses the image previews Lightroom has already generated, so it's much faster—even if the quality is less than perfect. For the best-looking results, leave draft mode off.

3. By default, Print Resolution is set to 240 ppi (pixels per inch), which is good for most photo printers. Leave Print Sharpening set to Standard, adjusting to Low or High only if your print looks like it could use a nudge in either direction.

4. Use the Media Type pop-up menu to choose Glossy or Matte, depending on the paper you are using.

5. In general, leave Profile in the Color Management section set to Managed by Printer. If you have installed a separate printer color profile, it appears in the Profile pop-up menu. (The printer's color settings are chosen as part of "To print photos" on page 196.)

✔ Tip

- Ⓜ You also can select 16 Bit Output in the Print Job panel if you are running Mac OS 10.5 and have a 16-bit printer.

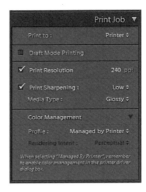

Figure 10.18
Use the Print Job to set print resolution, sharpening, and color management.

Figure 10.19
Before saving your settings as a custom template, make sure the main window shows the photos as you want them to be printed.

Figure 10.20 In the New Template dialog box, type in a name for your custom template.

Figure 10.21
The new template is added to the Template Browser panel.

Figure 10.22
Creating a custom print template enables you to use it again, but with different photos.

Saving a Custom Template

After customizing one of the pre-built templates and choosing your printer settings, you can save all of it as a custom template. After doing so, you can apply your custom template to any other photos with just a few clicks.

To save a custom template:

1. Take a moment to recheck the settings in the print-related panels. Also make sure that Lightroom's main window shows the photos as you want them to be printed (**Figure 10.19**).

2. Click the + (plus) in the Template Browser panel and when the New Template dialog box appears, type in a name for your template (**Figure 10.20**). Make sure the Folder is set to "User Templates" and click Create. The new template is added to the Template Browser panel (**Figure 10.21**). You are ready to print. See "Printing Photos" on the next page.

✔ Tip

- The real beauty of creating a custom print template is that you can use it again and again, but with different photos (**Figure 10.22**).

Printing Photos

If, as recommended in step 5 on page 194, you elected to let your printer manage your color, then now's the time to set that up. Printer dialog boxes run the gamut as far as where the color management settings are placed. The steps below offer typical examples. But be prepared to poke around your own printer's dialog boxes to find where these choices reside.

To print photos:

1. In the Print module, click the Print button at the bottom of the Right Panel Group (**Figure 10.23**).

2. When the printer dialog box appears, do one of the following based on whether you are running Windows or a Mac:

 W Click the Properties button and look for a color management or adjustment section (**Figure 10.24**). Inside the color management/adjustment section, look for an option to turn on ICM (Image Color Management) as your color management option (**Figure 10.25**). Choose OK or Save to apply the setting.

 M Look for a Color Matching section, choose ColorSync, and click Save or OK to apply the settings (**Figure 10.26**).

Figure 10.23
In the Print module, click the Print button at the bottom of the Right Panel Group.

Figure 10.24 **W** Printer dialog boxes vary greatly, but use the Properties button to find a color management or adjustment section.

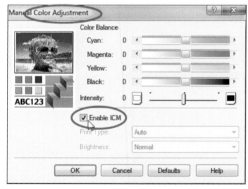

Figure 10.25 **W** Look for an option to turn on ICM (Image Color Management) as your color management option.

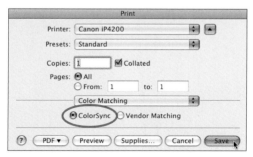

Figure 10.26 **M** Look for a Color Matching section, choose ColorSync, and click Save.

Figure 10.27
After choosing the printer's settings, you can use those same settings to print a single photo by simply clicking the Print One button.

3. Navigate back to the printer's main dialog box. Click OK or Print to begin printing a photo.

✔ Tips

■ Once you set the printer's color management, you can print future photos using those same settings by simply clicking the Print One button (**Figure 10.27**). For multiple copies, however, you need to click the Print button.

■ If you want to dive deep into the details of color management, take a look at Martin Evening's *The Adobe Photoshop Lightroom 2 Book: The Complete Guide for Photographers*, from Adobe Press.

■ If you have not calibrated your monitor, as explained on page 123, you will have problems creating prints with anywhere near the colors you see on your screen.

PRINTING PHOTOS

11

EXPORTING IMAGES

As long as you work within Lightroom, all your changes are saved as metadata. At some point, however, you may need to export those files so that you can burn them onto a disc or edit them in a non-metadata–based program like Photoshop. When exporting Lightroom files, you can save *copies* of your original images in four formats: JPEG for email or the Web, PSD for working in Photoshop, TIFF for print projects, or DNG (digital negative).

But you need not leave behind all the advantages of Lightroom since it can still keep track of images even when they are saved in other programs. When exporting photos, the Export dialog box includes an option to include them in the catalog—making it easier to find them within Lightroom. The Export dialog box also lets you stack the exports with the originals.

EXPORTING IMAGES

199

To export images:

1. In the Library module, use the Grid view or Filmstrip to select the photos you want to export.

2. From the Menu bar, choose File > Export (Ctrl-Shift-E/Cmd-Shift-E) or click the Export button at the bottom of the Left Panel Group (**Figure 11.1**).

3. When the Export dialog box appears, the top line notes how many files you are exporting (A, **Figure 11.2**). Each of the seven panels down the right side (B) offers a variety of drop-down menus and checkboxes to let you specify exactly how those files should be exported. By default, each collapsed panel lists the choices used in your last export. If you wish, you can adjust any of the following settings:

Preset: The Export dialog box's left panel (C) lists preset formats for some common export actions. If, for example, you select Burn Full-Sized JPEGs, Lightroom automatically switches to burning the files to a CD/DVD and fills in the relevant settings (**Figure 11.3**). All you need to do is click the dialog box's Export button.

Files on Disk / Files on CD/DVD: By default the upper-right drop-down menu is set to exporting Files on Disk (**Figure 11.4**). If you want to export the selected files to a CD or DVD, select that option in the drop-down menu.

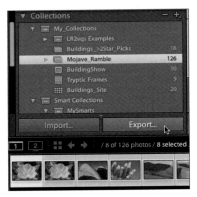

Figure 11.1 To export your selected images, choose File > Export (Ctrl-Shift-E/Cmd-Shift-E) or click the Export button at the bottom of the Left Panel Group.

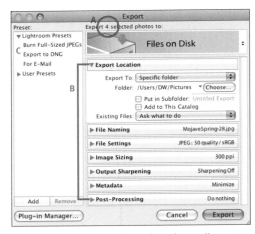

Figure 11.2 In the Export dialog box, the top line notes how many files you are exporting (A). The seven panels down the right side (B) let you specify exactly how those files should be exported. The left panel (C) lists preset formats for some common export actions.

Figure 11.4 Use the top-right drop-down menu to choose whether to export the files to disk or to a CD/DVD.

Figure 11.3 If you select a preset, Lightroom automatically applies the appropriate settings.

EXPORTING IMAGES

Figure 11.5 Use the Export Location panel to choose a destination for the exported files.

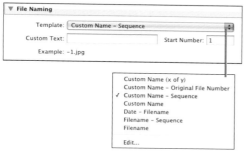

Figure 11.6 When naming exported files, the choices in the Template drop-down menu are identical to those available when you import images.

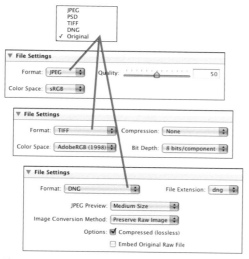

Figure 11.7 Depending on your choice in the Format drop-down menu, the File Settings panel offers choices appropriate for that format.

Export Location: Expand the panel and use the Export To drop-down menu (**A**, **Figure 11.5**) to pick a destination for the exported files. If you choose Specific folder, use the Choose button (**B**) to navigate to the folder or click the adjacent triangle to select a recently used folder. Select Put in Subfolder (**C**) to place the files in a new subfolder, which you name in the adjacent text box. You have the option of letting Lightroom keep track of the exported files by selecting Add to This Catalog (**D**). (As an added bonus, if the original files are part of a stack, Lightroom will add the exports to that same stack, which makes file tracking that much tidier.) Finally, the Existing Files drop-down menu (**E**) lets you control what happens if the names of the exported files conflict with file names already in the Lightroom catalog. (Selecting "Ask what to do" is the safest bet.)

File Naming: Expand the panel to set how the exported files are named (**Figure 11.6**). The various combinations are identical to those available when you import images into Lightroom. (For more information, see step 8 on page 20.)

File Settings: Expand the panel to set which file format is used (**Figure 11.7**). Depending on your format choice, the related options vary. A nice touch is that Lightroom automatically lists the appropriate Color Space based on your chosen format.

(continues on next page)

Image Sizing: If you chose TIFF or Original in step 8, this menu is dimmed since you would not want to resize the images. For all other formats, you can specify the exported file's maximum width and height (**Figure 11.8**). The Long Edge and Short Edge options are convenient when you have a mix of landscape and portrait images. By setting the Long Edge at 750 pixels, for example, you can control the longest edge—no matter what the orientation of a photo may be. Select Don't Enlarge if you want to preserve the original resolution (and avoid a pixelated image). (See Tip on page 204 about a bug in the Dimensions choice.)

Output Sharpening: New in Lightroom 2, this panel lets you apply sharpening based on the output destination (**Figure 11.9**). For example, select Screen in the Sharpen For drop-down menu if the exported photos are bound for a Web page. Select one of the two paper types if the final output will be a print. If you are exporting photos for eventual printing in *Photoshop*, this panel lets you apply *Lightroom's* sharpening beforehand.

Metadata: This panel lets you control what Lightroom metadata will remain embedded in the photo once it is exported (**Figure 11.10**). Choosing Minimize Embedded Metadata strips out all the metadata except the copyright information. The Write Keywords as Lightroom Hierarchy choice preserves some sense of the parent/child relationship of keywords even in applications that

Figure 11.8 The Image Sizing panel lets you specify the exported file's maximum width and height.

Figure 11.9 New in Lightroom 2, this panel lets you apply sharpening based on whether the exported files will be viewed on a screen or on paper.

Figure 11.10 The Metadata panel lets you control what Lightroom metadata remains embedded in the photo once it is exported.

Figure 11.11 The Post-Processing panel tells Lightroom what to do *after* the files are exported.

Figure 11.12
Click Add in the left panel to create an export preset based on your custom settings.

can only handle ASCII-based characters. For example, "Places > West US > Utah > Capitol Reef N.P." will be stored as "Places|West US|Utah|Capitol Reef N.P." where the | (the ASCII pipe character) is used as the delimiter between parent/child keywords. The last choice embeds a watermark in the photos to reduce the risk of others claiming them as their own.

Post-Processing: This panel is visible only if you chose Files on Disk in step 5. It's used to tell Lightroom what to do *after* the export is finished. In the expanded panel, make a selection in the After Export drop-down menu (**Figure 11.11**). By default, the menu is set to Do nothing, which is listed in the top section of the drop-down menu. Choices in the second section (**A**) include opening the Explorer/Finder folder in which the exported files are saved, opening them in Photoshop or opening them in another application. The third section (**B**) is visible only if you have created droplets using *Photoshop* and then saved them to *Lightroom's* Export Actions folder. You can look inside that folder by using the drop-down menu to choose Go to Export Actions Folder Now (**C**). If you have Photoshop, you can create and save any droplet to that Lightroom folder. (Explaining how to create Photoshop droplets, however, falls outside this book's coverage.)

4. After making all your choices in the Export dialog box's various panels, you can save them as a preset that you can use later. At the bottom of the left panel, click Add (**Figure 11.12**).

(continues on next page)

5. When the New Preset dialog box appears, type in a name for your export preset (**Figure 11.13**). Make sure the Folder is set to "User Presets" and click Create. The new export preset is added to the Preset panel of the Export dialog box (**Figure 11.14**).

6. Finally, you are ready to export the files. Click Export at the bottom of the Export dialog box (**Figure 11.15**). The selected photos are exported, and a task bar tracks the process (**Figure 11.16**), which can take several minutes if you are exporting many files or big files.

✔ Tip

■ In Lightroom 2 and 2.1, there is an Image Sizing bug you may encounter when using the Dimensions choice in the Image Sizing panel. Dimensions is supposed to apply the larger dimension to the longest side of your image, no matter its orientation. However, if you have a portrait-oriented image and enter the largest size in the *first* of the two fields, Lightroom actually applies the number in the *second* field as the largest dimension. You can work around this by using the Long Edge or Short Edge choices instead.

Figure 11.13 When the New Preset dialog box appears, name your export preset, set the Folder to User Presets, and click Create.

Figure 11.14
The new export preset is added to the Preset panel of the Export dialog box.

Figure 11.15 Once you have set how the exported files should be handled, click Export at the bottom of the Export dialog box.

Figure 11.16 As the selected photos are exported, Lightroom's task bar tracks the process.

EXPORTING IMAGES

Figure 11.17
To add third-party export plug-ins, click the Plug-in Manager button in the bottom corner of the Export dialog box.

Figure 11.18
When the Lightroom Plug-in Manager dialog box appears, click the Plug-in Exchange button to launch your Web browser.

Figure 11.19
When your Web browser takes you to the Adobe Lightroom Exchange, look at the page's right column under Browse By Category, and click the Export Plug-in link.

Figure 11.20 You can sort the list of export plug-ins several ways until you find one you'd like to download.

Adding Export Plug-ins

Lightroom makes it easy to add third-party export plug-ins, which give you even more choices for exporting photos. There are plug-ins, for example, to upload your photos directly to your online Flickr, SmugMug, or Facebook account. These are available through Adobe's online Lightroom Exchange, so you need to be connected to the Web before beginning.

To add an export plug-in:

1. From the Menu bar, choose File > Export (Ctrl-Shift-E/Cmd-Shift-E).

2. When the Export dialog box appears, click the Plug-in *Manager* button in the bottom-left corner (**Figure 11.17**).

3. When the Lightroom Plug-in Manager dialog box appears, click the Plug-in *Exchange* button, which also sits at the bottom left (**Figure 11.18**).

4. If it's not already running, Lightroom launches your default Web browser and takes you to the Adobe Lightroom Exchange. In the page's right column, under Browse By Category, click the Export Plug-in link (**Figure 11.19**).

5. A Lightroom Export Plug-in list appears, which you can sort in several ways (**Figure 11.20**). When you find something useful, download it.

6. After your browser downloads the file, double-click the file to unzip it and note what it is named.

(continues on next page)

7. In the Lightroom Plug-in Manager dialog box, which remains open, click the left panel's Add button (**Figure 11.21**).

8. Use the dialog box that appears to navigate to your browser's default downloads folder. Open the downloads folder and look for a file or folder with the name you noted in step 6. Once you find the actual plug-in file, select it, and click Add Plug-in (**Figure 11.22**).

9. The plug-in is added to the left list in the Lightroom Plug-in Manager dialog box (**Figure 11.23**). Click Done to close the dialog box.

10. You are returned to Lightroom's Export panel. Click the upper-right drop-down menu to find and launch your new export plug-in (**Figure 11.24**).

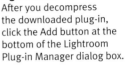

Figure 11.21 After you decompress the downloaded plug-in, click the Add button at the bottom of the Lightroom Plug-in Manager dialog box.

Figure 11.22 Once you find the plug-in file, select it, and click Add Plug-in.

Figure 11.23 Once the plug-in is added and activated in the Lightroom Plug-in Manager dialog box, click Done.

Figure 11.24 When you return to Lightroom's Export panel, use the upper-right drop-down menu to launch your new export plug-in.

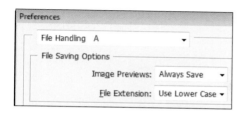

Figure 11.25 Set Photoshop's Preferences dialog box to work best with Lightroom by selecting File Handling in the drop-down menu (**A**, in CS2) or in the left panel (**B**, in CS3 or CS4).

Figure 11.26 Make sure the Maximize PSD and PSB File Compatibility preference is set to Always.

Meshing Lightroom and Photoshop

Thanks to Lightroom 2's new capabilities, such as local adjustments, you may find yourself doing less photo work in Photoshop. Inevitably, however, you will want to switch to Photoshop to work in layers or to use other tools not available in Lightroom. Thankfully, what's called roundtrip editing between Lightroom and Photoshop has grown simpler—and tidier. By setting Photoshop's preferences and using particular Lightroom commands, you can edit your photos in either program and still have Lightroom's catalog track all the images you generate.

To set Photoshop preferences for Lightroom:

1. Begin by opening Photoshop's Preferences (Ctrl-K/Cmd-K). When the Preferences dialog box appears, select File Handling in the drop-down menu (**A**, CS2) or in the left panel (**B**, CS3, CS4) (**Figure 11.25**).

2. Look for Maximize PSD and PSB File Compatibility and set it to Always (**Figure 11.26**). Click OK to close the dialog box. For now, you are done with Photoshop. See the next section on opening Lightroom images in Photoshop.

MESHING LIGHTROOM AND PHOTOSHOP

To edit Lightroom images in Photoshop:

1. In Lightroom's Library module, use the Grid view or Filmstrip to select the photos you want to edit within Photoshop.

2. Right-click (Control-click on a Mac) the selected photos and in the drop-down menu, choose Edit in and then one of the following:

 Edit in Adobe Photoshop: This option simply opens the photo in your most current version of Photoshop (**Figure 11.27**), where you can then make edits using any of that program's tools.

 Open as Smart Object in Photoshop: This option opens the photo as a special type of Photoshop layer called a "Smart Object" (**Figure 11.28**). In Photoshop, when you double-click a Smart Object layer, a Photoshop plug-in, Camera Raw, appears. Its controls work identically to those in Lightroom—and it saves your changes as metadata. It's like using Lightroom *from within* Photoshop. (For more on the wonders of the Camera Raw plug-in, see *Photoshop CS4* [or *CS3*] *for Windows and Macintosh: Visual QuickStart Guide,* by Elaine Weinmann and Peter Lourekas, also from Peachpit Press.)

 Merge to Panorama in Photoshop: This choice opens each image as a layer in Photoshop, which then seamlessly merges them into a composite panorama (Figure 11.28). (This option is available only if you have selected more than one photo.)

 Merge to HDR in Photoshop: This choice works much like the panorama option by merging each image as a layer. (It's available only if you have selected more than one photo.)

 Open as Layers in Photoshop: This option opens each photo as a separate layer within Photoshop, but does not

Figure 11.27 Right-click (Control-click on a Mac) the selected photos and choose Edit In > Edit in Adobe Photoshop for basic edits within Photoshop.

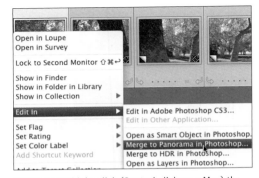

Figure 11.28 Right-click (Control-click on a Mac) the selected photos and choose Edit In > and pick one of the bottom four choices for specific editing tasks within Photoshop.

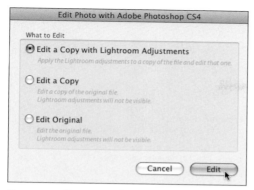

Figure 11.29 For non-raw formats, a Lightroom dialog box asks whether you want to use a *copy* or edit the *original* Lightroom file. Select Edit a Copy with Lightroom Adjustments.

Figure 11.30 After you save your changes in Photoshop, a copy with -Edit.psd added to the original name appears in the Lightroom catalog next to the original photo.

merge them. (This option is available only if you have selected more than one photo.)

3. If your photos use a raw format, Photoshop opens immediately, so go to step 4. For non-raw formats (JPEG, TIFF, PSD), a Lightroom dialog box appears asking whether you want to use a *copy* of the original Lightroom file or edit the *original* (**Figure 11.29**). By default, Lightroom selects the first choice, Edit a Copy with Lightroom Adjustments. Stick with that choice because it gives you the most flexibility when moving between Lightroom and Photoshop.

4. Photoshop launches and, based on your choice in step 2, either waits for you to make your edits or begins generating and merging layers.

5. Once you finish editing the photo in Photoshop, save the changes (Ctrl-S/Cmd-S). A copy is saved, with -Edit.psd added to the original name. This new file automatically appears in the Lightroom catalog next to the originally selected photos (**Figures 11.30, 11.31**).

Figure 11.31 After you save your uncropped panorama in Photoshop, a copy with -Edit.psd added to the original name appears in the Lightroom catalog next to the original photos.

MESHING LIGHTROOM AND PHOTOSHOP

INDEX

GET UP AND RUNNING QUICKLY!

For more than 15 years, the practical approach to the best-selling *Visual QuickStart Guide* series from Peachpit Press has helped millions of readers—from developers to designers to systems administrators and more—get up to speed on all sorts of computer programs. Now with select titles in full color, *Visual QuickStart Guide* books provide an even easier and more enjoyable way for readers to learn about new technology through task-based instruction, friendly prose, and visual explanations.

Task-Based
Information is broken down into concise, one- and two-page tasks to help you get right to work.

Visual
Hundreds of screen shots illustrate the steps and show you the best way to do them.

Step by Step
Numbered, easy-to-follow instructions guide you through each task.

Quick Reference
Tabs on each page identify the task, making it easy to find what you're looking for.

Tips
Lots of helpful tips are featured throughout the book.